OF WALKING IN ICE

Werner Herzog, *Of Walking in Ice*. Munich–Paris,
23 November–14 December 1974. Translated by
Martje Herzog and Alan Greenberg. University of
Minnesota Press, Minneapolis.

Originally published in Germany as
*Vom Gehem im Eis* by Carl Hanser Verlag.
First University of Minnesota Press edition, 2015;
published by arrangement with Jonathan Cape, London.
The University of Minnesota Press thanks Jeffrey
Schneider of Vassar College for his English
translation of "Tribute to Lotte Eisner."
English translation originally published
in the United States by Tanam Press, 1980
Published by the University of Minnesota Press
111 Third Avenue South, Suite 290
Minneapolis, MN 55401–2520
www.upress.umn.edu
Library of Congress Cataloging-in-Publication Data
Herzog, Werner.
Of walking in ice : Munich–Paris,
23 November–14 December 1974 / Werner Herzog
ISBN 978-0-8166-9732-8 (pb)
1. Herzog, Werner—Travel—Germany. 2. Herzog, Werner—
Travel—France. 3. Herzog, Werner—Diaries. I. Herzog,
Martje, translator. II. Greenberg, Alan, translator. III. Title.
PT2668.E774V6513 2015
838'.91403—dc23        2014040586
Printed in the United States of America on acid-free paper
The University of Minnesota is an
equal-opportunity educator and employer.
25 24            10 9 8 7 6 5

# WERNER

# HERZOG

# OF WALKING

# IN ICE

At the end of November 1974, a friend from Paris called and told me that Lotte Eisner was seriously ill and would probably die. I said that this must not be, not at this time, German cinema could not do without her now, we would not permit her death. I took a jacket, a compass, and a duffel bag with the necessities. My boots were so solid and new that I had confidence in them. I set off on the most direct route to Paris, in full faith, believing that she would stay alive if I came on foot. Besides, I wanted to be alone with myself. What I wrote along the way was not intended for readers. Now, four years later, upon looking at the little notebook once again, I have been strangely touched, and the desire to show this text to others unknown to me outweighs the dread, the timidity to open the door so wide for unfamiliar eyes. Only a few private remarks have been omitted.

W.H. / DELFT, HOLLAND, 24 MAY 1978

WERN

HERZ

OF WAL

IN I

Right after five hundred meters or so I made my
first stop, near the Pasinger Hospital, from where I
wanted to turn west. With my compass I gauged the
direction of Paris; now I know it. Achternbusch had
jumped from the moving VW van without getting
hurt, then right away he tried again and broke his
leg; now he's lying in Ward 5.

The River Lech, I said to him, that will be the
problem, with so few bridges crossing it. Would the
villagers row me across in a skiff? Herbert will tell
my fortune, from cards as tiny as a thumbnail, in
two rows of five, but he doesn't know how to read
them because he can't find the paper with the inter-
pretations. There is the Devil, with the Hangman
in the second row, hanging upside down.

Sunshine, like a day in spring, that is the Sur-
prise. How to get out of Munich? What is going
on in people's minds? Mobile homes? Smashed-up
cars bought wholesale? The car wash? Meditating

on myself makes one thing evident: the rest of the world is in rhyme.

One solitary, overriding thought: get away from here. People frighten me. Our Eisner mustn't die, she will not die, I won't permit it. She is not dying now because she isn't dying. Not now, no, she is not allowed to. My steps are firm. And now the earth trembles. When I move, a buffalo moves. When I rest, a mountain reposes. She wouldn't dare! She mustn't. She won't. When I'm in Paris she will be alive. She must not die. Later, perhaps, when we allow it.

In a rain-sodden field a man catches a woman. The grass is flat with mud.

The right calf might be a problem, possibly the left boot as well, up front on the instep. While walking, so many things pass through one's head, the brain rages. A near-accident now a bit further ahead. Maps are my passion. Soccer games are starting, they are chalking the center line on plowed fields. Bavarian flags at the Aubing (Germering?) transit station. The train swirled up dry paper behind it, the swirling lasted a long time, then the train was gone. In my hand I could still

feel the small hand of my little son, this strange little hand whose thumb can be bent so curiously against the joint. I gazed into the swirling paper and it gave me a feeling, as if my heart was going to be ripped apart. It is nearing two o'clock.

Germering, tavern, children are having their first communion; a brass band, the waitress is carrying cakes and the regular customers are trying to swipe something from her. Roman roads, Celtic earthworks, the Imagination's hard at work. Saturday afternoon, mothers with their children. What do children at play really look like? Not like this, as in movies. One should use binoculars.

All of this is very new, a new slice of life. A short while back I stood on an overpass, with part of the Augsburg freeway beneath me. From my car I sometimes see people standing on the freeway overpasses, gazing; now I am one of them. The second beer is heading down to my knees already. A boy stretches a cardboard barricade between two tables with some string, securing it at both ends with Scotch tape. The regulars are shouting, "Detour!" "Who do you think you are?" the waitress says. Then the music starts playing very loudly again.

The regulars would love to see the boy reach under the waitress's skirt, but he doesn't dare.

Only if this were a film would I consider it real.

Where I'm going to sleep doesn't worry me.
A man in shiny leather jeans is going east. "Katharina!" screams the waitress, holding a tray of pudding level with her thighs. She is screaming southward: that I pay attention to. "Valente!" one of the regulars screams back, referring to a crooner of the good old days. His cronies are delighted. A man at a side table whom I took for a farmer suddenly turns out to be the innkeeper, with his green apron. I am getting drunk, slowly. A nearby table is irritating me more and more with its cups, plates, and cakes laid out but with absolutely no one sitting there. Why doesn't anybody sit there? The coarse salt of the pretzels fills me with such glee I can't express it. Now all of a sudden the whole place looks in one direction, without anything being there. After these last few miles on foot I am aware that I'm not in my right mind; such knowledge comes from my soles. He who has no burning tongue has burning soles. It occurs to me that in front of the tavern was a haggard man sitting in

a wheelchair, yet he wasn't paralyzed, he was a
cretin, and some woman who has escaped my mind
was pushing him. Lamps are hanging from a yoke
for oxen. In the snow behind the San Bernardino
I nearly collided with a stag—who would have
expected a wild animal there, a huge wild animal?
With mountain valleys, trout come to mind again.
The troops, I would say, are advancing, the troops
are tired, for the troops the day is done. The inn-
keeper in the green apron is almost blind, his face
hovering inches from the menu. He cannot be a
farmer, being almost blind. He is the innkeeper,
yes. The lights go on inside, which means the day-
light outside will soon be gone. A child in a parka,
incredibly sad, is drinking Coke, squeezed between
two adults. Applause now for the band. The fare
tonight shall be fowl, says the innkeeper in the
Stillness.

Outside in the cold, the first cows; I am moved.
There is asphalt around the dung heap, which is
steaming, then two girls traveling on roller skates.
A jet-black cat. Two Italians pushing a wheel
together. This strong odor from the fields! Ravens
flying east, the sun quite low behind them. Fields

soggy and damp, forests, many people on foot. A
shepherd dog steaming from the mouth. Alling,
five kilometers. For the first time a fear of cars.
Someone has burned illustrated papers in the field.
Noises, as if church bells were ringing from spires.
The fog sinks lower; a haze. I am stock-still,
between the fields. Mopeds with young farmers
are rattling past. Further to the right, toward the
horizon, many cars because the soccer match is
still in progress. I hear the ravens, but a denial is
building up inside me. By all means, do not glance
upward! Let them go! Don't look at them, don't lift
your gaze from the paper! No, don't! Let them go,
those ravens! I won't look up there now! A glove
in the field, soaking wet, and cold water lying in
the tractor tracks. The teenagers on their mopeds
are moving toward death in synchronized motion.
I think of unharvested turnips but, by God, there
are no unharvested turnips around. A tractor
approaches me, monstrous and threatening, hoping
to maul me, to run me over, but I stand firm. Pieces
of white Styrofoam packaging to my side give me
support. Across the plowed field I hear faraway con-
versations. There is a forest, black and motionless.

The transparent moon is halfway to my left, that is, toward the south. Everywhere still, some single-engine aircraft take advantage of the evening, before the Goon comes. Ten steps further: the Business that Stalketh about in the Dark will come on Saint Oblivious Day. Where I am standing lies an uprooted, black and orange signpost; its direction, as determined from the arrow, is northeast. Near the forest, utterly inert figures with dogs. The region I'm traversing is infested with rabies. If I were sitting in the soundless plane right above me, I would be in Paris in one and a half hours. Who's chopping wood? Is that the sound of a church clock? So, now, onward.

How much we've turned into the cars we sit in, you can tell by the faces. The troops rest with their left flank in the rotting leaves. Blackthorn presses down on me—as a word, I mean, the word *blackthorn*. There, instead, lies a bicycle rim entirely devoid of inner tube, with red hearts painted around it. At this bend I can also tell by the tracks that the cars have lost their way. A woodland inn wanders past, as big as a barrack. There is a dog— a monster—a calf. At once I know he will attack me,

but luckily the door flies open and, silently, the calf passes through it. Gravel enters the picture, then gets under my soles; before this, one could see movements of the earth. Pubescent maidens in miniskirts are getting set to climb onto other teenagers' mopeds. I let a family pass by me; the daughter is named Esther. A cornfield in winter, unharvested, ashen, bristling, and yet there is no wind. It is a field called Death. I found a white sheet of homemade paper on the ground, soaking wet, and I picked it up, craving to decipher something on the top side, which was turned toward the wet field. Yes, *it* would be written. Now that the sheet seems blank, there is no disappointment.

At the Doettelbauers' everybody has locked up everything. A beer crate with empty bottles waits for delivery at the roadside. If only the shepherd dog (that is to say, the Wolf!) wasn't so hot for my blood, I could do with the dog kennel for the night, since there's straw in it. A bicycle comes and, with each full turn, the pedal strikes the chain guard. Guard rails next to me, and over me, electricity. Now it passes over my head crackling from the high voltage. This hill here invites No One to Nothing.

Just below me, a village nestles in its lights. Far to the right, almost silent, there must be a busy highway. Conical light, not a sound.

How frightened I was when, before reaching Alling, I broke into a chapel to possibly sleep inside, and there was a woman with a St. Bernard dog, praying. Two cypresses in front let my fright pass through my feet into the bottomless pit. In Alling not a single tavern was open; I poked about the dark cemetery, then the soccer field, then a building under construction where window fronts are secured with plastic covers. Someone notices me. Outside Alling a matted spot—peat huts, it appears. I startle some blackbirds in a hedge, a large, terrified swarm that flies recklessly into the darkness ahead of me. Curiosity guides me to the right place, a weekend cottage, garden closed, a small bridge over the pond, barred. I do it the direct way I learned from Joschi. First a shutter broken off, then a shattered window, and here I am, inside. A bench along the corner walls, thick ornamental candles, still burning; no bed, but a soft carpet; two cushions and a bottle of undrunk beer. A red wax seal in a corner. A tablecloth with a modern design

from the early fifties. On top of it a crossword puzzle, one-tenth solved with a great deal of effort, but the scribbling inside the margin reveals that every verbal resource had been tried. Solved are: Head covering? Hat. Sparkling wine? Champagne. Call box? Telephone. I solve the rest and leave it on the table as a souvenir. It's a splendid place, well beyond harm's way. Ah, yes. Oblong, round? it says here, vertical, four letters, ends with L in Telephone, horizontal: the solution hasn't been found, but the first letter, the first square is circled several times with a ballpoint pen. A woman who was walking down the dark village road with a jug of milk has occupied my thoughts ever since. My feet are fine. Are there trout, perhaps, in the pond outside?

Sunday 24 November

Fog outside, so icy cold that I can't describe it. On
the pond swims a membrane of ice. The birds wake
up, noises. On the landing my steps sound so hol-
low. I dried my face in the cottage with a towel that
was hanging there; it reeked so bitterly of sweat
that I'll carry the stench around with me all day
long. Preliminary problems with my boots, still so
new that they pinch. I tried using some foam, and,
with every movement wary like an animal, I think
I possess the thoughts of animals as well. Inside,
beside the door, hangs a chime, a set of three small
goatbells with a tongue in the middle and a tassel
for pulling. Two nut bars to eat; perhaps I'll reach
the Lech today. A host of crows accompanies me
through the fog. A farmer is transporting manure
on a Sunday. Cawing in the fog. The tractor tracks
are deeply embedded. In the middle of a courtyard
there was a flattened, gigantic mountain of wet,
filthy sugar beets. Angerhof: I've lost my way. Sun-
day bells from several villages in the fog all at once,

most likely the start of church services. Still the crows. Nine o'clock.

Mythical hills in the mist, built from sugar beets, lining the path through the field. A hoarse dog. I think of Sachrang, as I cut off a piece from the beet and eat it. It seems to me the syrup had a lot of foam on top; the taste brings back the memory. Holzhausen: the road emerges. By the first farm, something harvested, covered with a plastic tarp anchored with old tires. You pass a lot of discarded rubbish as you walk.

A brief rest near Schöngeising, along the River Amper; matted countryside, meadows at the edge of a forest, rimmed with rifle ranges. From one rifle range you can see Schöngeising; the fog clears, jays appear. In the house last night I peed into an old rubber boot. A hunter, with a second hunter nearby, asked me what I was looking for up there. I said I liked his dog better than I liked him.

Wildenroth, "The Old Innkeeper" tavern. Followed the Amper; empty, wintry weekend cottages. An elderly man, enveloped in smoke, was standing by a dwarf pine, filling the house of a titmouse with food; the smoke was rising from his chimney.

I greeted him and hesitated before asking if he had some hot coffee on the stove. At the entrance to the village I saw an old woman, small, bowlegged, madness etched across her face; she pushed a bicycle, delivering the Sunday papers. She stalked the houses as if they were The Enemy. A child wants to play pick-up sticks with plastic straws. The waitress is eating right now; here she comes, chewing.

A harness hangs in my corner and within it a red streetlight is mounted for lighting, a loudspeaker above. Zither music and yodeled "Hollereidi," my beautiful Tyrol comes from on high.

A cold mist rises from the plowed, broken fields. Two Africans were walking in front of me making thoroughly African hand gestures, deeply engrossed in conversation. To the very end they didn't notice I was behind them. The most desolate thing was the palisades of Hot Gun Western City, here in the middle of the forest, all dreary, cold, void. A railway that will never run again. The journey is getting long.

For miles across open fields I followed two teenage village beauties along a country road. They were walking a little slower than I, one of them in a

miniskirt with a handbag, and after several miles I steadily drew close to them. They saw me from far away, turned around, quickened their pace, then stepped a bit slower again. Only when we were within reach of the village did they feel safe. When I overtook them I had the feeling they were disappointed. Then a farmhouse at the edge of town. From a distance I could see an old woman on all fours; she wanted to get up but couldn't. I thought at first she was doing something like push-ups, but she was so rigid she couldn't get up. On all fours she worked her way to the corner of the house, behind which were people who belonged to her. Hausen, near Geltendorf.

From a hillock I gaze across the countryside, which stretches like a grassy hollow. In my direction, Walleshausen; a short way to the right, a flock of sheep; I hear the shepherd but I can't see him. The land is bleak and frozen. A man, ever so far away, crosses the fields. Phillipp wrote words in the sand in front of me: *ocean, clouds, sun,* then a word he invented. Never did he speak a single word to anyone. In Pestenacker, people seem unreal to me. And now the question, where to sleep?

Monday 25 November

Night near Beuerbach in a barn, downstairs serving
as a shelter for the cows, the earth like clay and
deeply trampled down. Up above it's passable, only
light is missing. The night seemed long, but it was
warm enough. Deep clouds outside sweep by, it is
stormy, everything seems grey. The tractors have
their headlights on, although there is light enough.
After precisely one hundred meters a roadside
shrine with little pews. What a sunrise behind me.
The clouds had split open a crack; yes, a sun like
that rises bloodied on the day of Battle. Meager,
leafless poplars, a raven flying although missing a
quarter of his wing, which means rain. Beautiful,
dry grass around me, rocking itself in the storm.
Right in front of the pew a tractor track in the dirt.
The village is dead silent, telling of deeds done from
which it refuses to wake. The first traces of blisters
on both heels, especially the right one; to put on my
shoes requires a great deal of care. I must get as far

as Schwabmuenchen, for Band-Aids and money.
The clouds are drifting against me. My God, how
heavy the earth is from the rain. Turkeys are
screaming with alarm from a farmhouse behind me.

Outside of Klosterlechfeld. Now I can see that the
Lech would be no problem, even without a bridge.
The terrain reminds me of Canada. Barracks, sol-
diers in huts of corrugated iron, bunkers from the
Second World War. A pheasant took off just three
feet in front of me. There's fire from a tin oil drum.
A deserted bus stop; children have emblazoned it
with colored chalk. Part of a wall made of corru-
gated plastic is banging in the wind. A sticker here
notifies us that the power will be turned off tomor-
row, but for a hundred meters around me there's
nothing electrical to be seen. Rain. Tractors. The
cars still have their lights on.

Raging storm and raging rain from the River
Lech to Schwabmünchen: nothing noticed but
this. In the butcher's shop I stood waiting for ages,
brooding Murder. The waitress in the inn under-
stood it all in a glance, which did me good, so now
I'm feeling better. Outside, a radio patrol car and

police; I'll make a long detour around them later. While changing my large note in the bank, I had a definite feeling the teller would sound the alarm at any moment, and I know I would have run instantly. All morning I was ravenously hungry for milk. From now on I have no map. My most pressing needs: Band-Aids, a flashlight.

When I looked out the window, a raven was sitting with his head bowed in the rain and didn't move. Much later he was still sitting there, motionless and freezing and lonely and still wrapped in his raven's thoughts. A brotherly feeling flashed through me and loneliness filled my breast.

Hail and storm, almost knocking me off my feet with the first gust. Blackness crept forth from the forest and at once I thought, this won't end well. Now the stuff's turning into snow. On the wet road I can see my reflection below me. For the past hour continual vomiting, only little mouthfuls, from drinking the milk too fast. The cows here break into a gallop quite unexpectedly. Refuge in a bus stop of rough stained wood, open to the west so that the snow blows into the most distant corner, where

I am. Along with the storm and snow and rain, leaves are swirling as well, sticking to me and covering me completely. Away from here, onward.

A brief rest in a stretch of woodland. I can look into the valley, as I take the shortcut over wet, slushy meadows; the road here makes a wide loop. What a snowstorm; now everything's calm again, I'm slowly drying out. Mickhausen ahead of me, wherever the hell that is. Raindrops are still falling from the fir trees to the needle-covered ground. My thighs are steaming like a horse. Hill country, lots of woodland now, everything seems so foreign to me. The villages feign death as I approach.

Just before Mickhausen (Muenster?), turning further west, following my instincts. Blisters on the balls of my toes give me trouble; had no idea that walking could hurt so much. High on a telephone pole a repairman was hanging by his straps undaunted, shamelessly staring down at me, the Man of Sorrows, entrusting his weight to the taut strap while smoking a pipe. His glance followed me for a long time as I crept past below. Suddenly I stood rooted by my feet, then turned on my heel and stared back. All at once a cave in the craggy slope

behind me howled down to the sea with its mouth
wide open. The rivers streamed converging to their
end in the sea, with the Grotesque also cowering
in a crowd on the coast, just like everywhere else
on this Earth. Overwhelming all was a sudden,
strange, otherworldly whistling and whining in the
air, from the gliders circling over the slopes. Fur-
ther on, toward the rising sun where the thunder of
faraway guns was rumbling, a radar on a mountain-
top, mysterious and forever taciturn, like a huge
eavesdropping ear, yet also emitting shrieks that
no one can hear, reaching into fathomless space.
Nobody knows who built the station, who runs it,
to whom it addresses itself. Or does the repairman
strapped to the pole have something to do with it?
Why is he staring after me like that? The radar sta-
tion is often shrouded in clouds, then they scatter
and the sun goes down, days passing as I stand
there, and still the station glares fixedly at the ulti-
mate edges of the universe. Over the mountain for-
est outside Sachrang, in the last days of the War, an
aeroplane dropped a metal device that was visible
in the treetops by its flag. We children were certain
the flag was wandering from tree to tree, that the

mysterious device was moving forward. During the night some men went off and, when they returned at daybreak, they refused to divulge information concerning what they had found.

Beautiful hilly countryside, a great deal of forest, all is still. A hawk screeches. On the prayer cross behind me is written:

Ere night falls, all can swiftly change
And have a different face from early morn.
On earth a restless stranger was I born
In mortal danger, though in the midst of life.
Through Christ's blood for me my God pray send
Some good end to all this strife.
Our time is high, Eternity draws nigh.

I noticed that the road turned more and more southward; thus, cross-country. Kirchheim, then, around a forest, dusk approaching. Obergessertshausen: no break, since it is almost totally dark. I'm rambling more than walking. Both legs hurt so much that I can barely put one in front of the other. How much is one million steps? Uphill toward Haselbach, in the darkness I can discern something but, stumbling forward, it turns out to be just a

thoroughly filthy shelter for cows. The ground is trampled knee-deep in wet clay by their hooves, and my feet collect pounds of heavy, sticky clods of earth at once. On a rise before Haselbach two holiday homes, the prettier of which I break into without causing any damage. Remnants of a feast inside, it can't be long ago. A pack of cards, an empty beer mug, the calendar showing November. Outside there's a storm and inside there are mice. How cold it is!

Tuesday 26 November

Things are somewhat clearer now having bought a
Shell Oil map in Kirchheim. During the night there
was a bad storm; in the morning, snow was melting
everywhere in tatters. Rain, snow, and hail, those
are the Lower Orders. Upon closer inspection, the
hut contained a flail and pitchfork on the walls to
give it a rustic touch, walking sticks covered with
emblems, pitchforks forming a cross, and another
calendar with the Playmate of the Month for Sep-
tember. Above the window were photo-booth por-
traits of the inhabitants, which reminded me a lot
of people like Zef and the Limp. The man at the
petrol station gave me such an unreal look that I
rushed to the john to convince myself in front of the
mirror that I was still looking human. So what—
I'll let the storm blow me around the petrol station
until I get wings. Tonight I'll be King of the house
I break into next, and the house my castle. Once set
going, a kitchen alarm clock intones a great Last

Judgment. The wind worries the woods outside. This morning Night was drowned on cold, grey waves. The cigarette packets on the roadside fascinate me greatly, even more when left uncrushed, then blown up slightly to take on a corpse-like quality, the edges no longer sharp and the cellophane dimmed from inside from the dampness, forming water droplets in the cold.

Lotte Eisner, how is she? Is she alive? Am I moving fast enough? I don't think so. The countryside's so empty and has the same forsaken sense for me as during that time in Egypt. If I actually make it, no one will know what this journey means. Trucks drive by in dreary rain. Kirchberg—Hasberg—Loppenhausen, a place that needs no comment. Last, toward the west, a small colony of shacks, all quite provisional, as if gypsies were living there, having settled only half-heartedly. I look further on through the forest. The fir trees sway against each other, crows are rushing against the strong wind, making no headway. Upon long stalks of rye a whole community has been built, on each stalk a house. The houses waver majestically atop their stalks, the entire community swinging and swaying.

The hawk sustains itself against the wind above the fir trees, remaining in one spot, then it is borne aloft and changes its course. A roebuck jumped across the road and slipped on the asphalt, as if it were a polished parquet floor. It's very cold, ahead of me some snow has fallen, still a little left in the flattened grass. A branch has grown through a tree trunk; over this I lost my composure, plus there was the barking of dogs from some dead village. How I long to see someone kneeling before the roadside crosses! Low-flying aeroplanes overhead all day, one coming so close once that I think I saw the pilot's face.

Kettershausen: a great effort to get that far, with such deep exhaustion inside me. No more thoughts. Wasn't there an old pensioner on a leather sofa in an inn, who warmed his beer with a beer warmer? Wasn't the red-faced innkeeper close to having a stroke? I can hardly understand the dialect around here. Matzenhofen, Unterroth, Illertissen, Vöhringen.

Wednesday 27 November

Vöhringen: spent the night in an inn. In the morning bought Band-Aids and pale brandy for my feet right away. Outside there is a wild snowfall. Staring forever into the flakes. I saw a procession of nuns together with high school students, sauntering with arms around each other's shoulders and hips, thus demonstrating ostentatiously that this meant nothing, that the nuns were modern in their thinking nowadays. The whole arrangement smacked of bogus gaiety and insouciance, while reeking of hypocrisy. One of the nuns displayed a tattooed eagle on her low-cut neckline, extending from one shoulder blade to the other. Then I saw Wolfgang from behind on Amalienstrasse. I recognized him at once. He was thinking so intensely that he punctuated his thoughts with vehement gestures, as if he were speaking. He vanished in a flurry of snowflakes that were advancing toward me from an abandoned house.

Bridge spanning the Iller, path in the direction of Beuren through a forest, all at once a vast clearing. Everywhere the forest was staring, vast and black and deathly, rigidly still. From the pit of the woods came the screech of a buzzard. Beside me a water-filled ditch, the long grass in it flattened down. The water's so transparent that I wonder why the ditch hasn't frozen over. I kicked a bit of frost onto it with my boot and, yes, there was a thin layer of ice on top after all, as transparent as an aquarium's walls. A loneliness like this has never come over me before. In the forest a little further on was a chapel at a crossroads. The steps led directly into a puddle of ice-clear water; at the bottom lay dirty oak leaves. What a stillness surrounded me.

Earthworms on the asphalt road have tried to flee from the frost. They are all very thin and stretched out. A nuthatch was tapping on a tree and I stood there a while, listening to him, as it soothed me. A little further on, in the loneliest spot, the very loneliest spot, I saw a fox. The tip of his tail had turned white. Schnürpflingen—Bihalfingen— I sit in a covered bus stop, the school nearby is having break. A child approached, saluted, then ran

away. The priest has a word for me, in passing. The children are devoured by the school. Sparrows are melting from the roof in drops. There are still some frozen apples in the naked trees uphill.

Laupheim, train station restaurant: bought a *Süddeutsche* newspaper, having no idea what's going on in the world. It confirmed that today is only Wednesday, as I'd had my doubts. Untersulmetingen, then through the forest, a quiet forest with clover leaves on the snowy, wet ground. While I was taking a shit, a hare came by at arm's length without noticing me. Pale brandy on my left thigh, which hurts from my groin down with every step. Why is walking so full of woe? I encourage myself, since nobody else encourages me. Bockighofen—Sontheim—Volkertsheim. In Sontheim, a policeman who saw me made a wry face and checked me. Spending the night is going to be difficult, the area is bad. Industry, smells of sewage, silo fodder, and cow dung.

Thursday 28 November

Beyond Volkertsheim spent the night in a barn;
all around there was nothing else, and so I stayed,
although it was only 4:30. What a night. The storm
raged so that the whole shack, which was solidly
built, began to shake. Rain and snow came sprin-
kling in from the rooftop and I buried myself in the
straw. Once I awoke with an animal sleeping on my
legs. When I stirred it was even more frightened
than I was. I think it was a cat. The storm grew so
fierce that I can't recall having experienced any-
thing like it. A black morning, gloomy and cold,
a morning that spreads itself over the fields like a
pestilence, as only after a Great Calamity. The side
of the shed facing the wind is piled high with snow,
the fields a deep black, with white lines of snow.
The storm was so powerful that the snow never
settled into the furrows. Deep, sweeping clouds.
The smallest heights, rising but a hundred meters
higher up, have a white blanket of snow. Partridges,

contrasting with the landscape only when they fly away. I have never cast eyes on such a gloom-laden land. The snow has drifted against the road signs and the entire surface of snow has slid down somewhat, but still it sticks. I reached the Danube near Rottenacker, the bridge there was such a landmark for me that I spent a long time looking into the water. There was a grey-speckled swan, fighting against the current, but he remained in one spot, unable to swim more swiftly than the current. Behind him the grating of a mill, before him water rushing abruptly down, leaving him just a small sphere of activity. After a period of turbulent tumbling and churning there, he is forced to return to the shore. Construction trucks, dirt from tractor treads, tempestuous winds, low clouds. I suddenly find myself among school kids—school's out. At the edge of the village they scrutinize me, I scrutinize them.

Munderkingen. Again my left thigh starts acting up around the groin, making me mad, for otherwise it would be fine. Here is a country fair and cattle market, everywhere farmers in Wellingtons, pig transports, cows. I bought myself a cap, a kind of

storm hat, a bit too small and utterly repulsive. Then long johns. Just outside town, a small church to one side and an inhabited trailer right next to it. An old man came out, and for a long while he bent over bare, severely trimmed rosebushes. I undressed in a corner of the church, while the wind was swirling a solitary tree leaf round my head. In the distance the thunder of cannon and jet fighters, which is how my mother described the outbreak of the War. A few miles further on, a low-flying jet fighter attacked a hedge, the hedge firing back from all barrels; it was nothing but a camouflaged tank that spun about and fired in a flash, while the jet fighter attacked from all angles.

Ugly road, then Zwiefalten, the beginning of the Swabian Alb, everything further up densely packed with snow. A farmer's wife told me of the snow-storm and I kept quiet about it. Geisingen, tired humans in neglected villages who no longer expect anything more for themselves. Snowy silence, the black fields once again peeking out bleakly from beneath the snow. For years the doors of Genkingen have been banging in the wind. I saw sparrows on a

dung heap that has stopped steaming. Melting snow trickles into a drainage hole. The legs keep going.

Beyond Geising the snowfall starts to turn into a squall and I walk more aggressively, for stopping would mean I'd start to freeze at once, as I'm soaked to the skin, so in this way I can at least keep the machine running. Wet, driving snow falls intensely in front, sometimes from the side as well, as I compulsively lean into it, the snow covering me immediately, like a fir tree, on the side exposed to the wind. Oh, how I bless my cap. On old brown photos the last Navajos, crouching low on their horses, wrapped in blankets, covered in rugs, move through the snowstorm toward their doom: this image refuses to leave my mind and strengthens my resolve. The road is quickly buried in drifts of snow. In the blizzard a truck gets stuck in the muck of the field with its lights on and cannot move; the farmer standing next to it gives up, not knowing what to do. The two of us, specters both, don't salute. Oh, it's such a hard march as the wind bearing burning snow blows bitingly into my face, completely horizontal. And most of the time it's all uphill, though

downhill everything hurts as well. I am a ski jumper, I support myself on the storm, bent forward, far, far, the spectators surrounding me a forest turned into a pillar of salt, a forest with its mouth open wide. I fly and fly and don't stop. Yes, they scream. Why doesn't he stop? I think, better keep on flying before they see that my legs are so brittle and stiff that they'll crumble like chalk when I land. Don't quit, don't look, fly on. Then a dwarfish winegrower on a tractor, then my little one listened to my chest to see if my heart was still beating. The watch I gave him is also going, he says it's ticking. I always wanted a postcard from the dam that burst in Fréjus, because of the landscape. And in Vienna, when the old Danube bridge crashed down at dawn, an eyewitness who had wanted to cross said that the bridge had flattened out like an old man going to sleep. All around there are cornfields, which calls for more thinking.

My right ankle has worsened. If it goes on swelling I won't know what to do. I cut across the curves sloping downward to Gammertingen, it's getting so steep and it really hurts. At a sharp turn my left leg suddenly tells me what a meniscus is, as

heretofore I'd known it only in theory. I'm so dramatically wet that before entering an inn I hesitate outside for quite a long time. But necessity forces me to overcome my worst fears. Haile Selassie was executed. His corpse was burned together with an executed greyhound, an executed pig, and an executed chicken. The intermingled ashes were scattered over the fields of an English county. How comforting this is.

Friday 29 November

Not a good night, therefore somewhat plaintive in
the morning. Telephoned from the post office. An
ugly, much-frequented road to Neufra over a range
of hills. A direct route cross-country is hardly possi-
ble. A terrible storm up in Bitz, everything's cov-
ered with snow. Beyond Bitz, up a forested slope, a
furious flurry of snow breaks out in the forest, the
flakes circling down from above like a whirlwind.
I don't dare venture into the open fields any more
since the snow there blows horizontally. For many
years they haven't had anything remotely like this,
and it's not even December yet. A truck on a nearby
road picks me up; it is able to advance cautiously,
only at a man's pace. Together we push a stranded
car out of the snow. In Truchtelfingen I become
aware that there's no way to proceed, the snow-
storm's becoming a Madness. Tailfingen, again at
an inn, I hang up my clothes. A standstill all day
long, no movement, no thoughts, I've come to a

standstill. The town is awful, quite a lot of indus-
try, cheerless Turks, just one telephone booth.
Very pronounced loneliness, also. The little one
must be lying in bed by now, clinging to the edge
of his blanket. Today, I'm told, they're already show-
ing the film at the Leopold; I do not dare to believe
in justice.

Saturday 30 November

Still in Tailfingen. It all started with a tunnel where
the parked cars were being ticketed by the police.
We drove past hollering, doing something that isn't
done. Once, at home, I wanted to tidy up the messy
car a bit, and along the way I threw out everything,
mostly old scraps of paper. Suddenly I found two
police magazines amid a pile of junk, and inside
them were two pictures of such beauty that I'd
never seen anything like them before. They were
pictures of a land that took my breath away. But
how did something like this get into a police publi-
cation? I walked in this land, walked a blissful way
below a blissful group of giant trees. On the tree-
tops above there was a blissful house, a very flat-
roofed palace made of simple bark and bamboo
blended together, but blissful beyond conception.
Parrots screeched, then women and children
screamed. Nutshells fell to the ground from some
sort of nuts being eaten by someone up above.

I instantly knew it was the Cambodian palace of
Lon Nol. The thought just plagued me how all this
was possible, since he's been paralyzed by a stroke.
Then there was the Richthofen's mobile home
parked out there, the man being D. H. Lawrence.
The children were lying on the seats in front, a girl
eleven, the boy ten years old. The parents were
sleeping in the rear; the children get up to pee.
A military vehicle silently approaches, leading a
strange procession that no one's supposed to see.
The children aren't detected since they're stand-
ing in the shadow of some bushes. A column of
wounded people is carried by on stretchers, but they
are so fearfully disfigured that the population is for-
bidden to look at them. Nurses accompany them,
holding up bags filled with intravenous fluids, and
all of the wounded are joined to one another system-
atically, forming a chain. The fluid flows from one
body to the next one, and so on. One man in the
middle of the procession dies while being trans-
ported, and one of the Cambodian nurses sleeps
through this. Upon discovery she is scolded because
the fluid cannot pass through the dead person to the
next wounded one, so the whole row after him is

drying out. Then a double-decker aircraft came, an antiquated model, piloted so precisely that it lifted a handkerchief up from the ground with the tip of its wing. I manufactured napalm along with Farocki, and we experimented with it out in an open field of rubbish; we needed it urgently for a demonstration of terror. We were seized but we lied about it. I heard crows and jumped up and ripped open the window, and a whole swarm of crows flew through near-darkness over the city. Everything is white with snow, the city is flooded with snow. The morning emerges from utter Blackness, this isn't a dream. Before the big department store opens, a salesman brings the rocking horse outside on a cart, connecting it with a cable to the electrical current. Everywhere the shop owners are clearing their pavements with shovels.

Deep snow beyond Pfeffingen; water runs down the wooded slope to the road below at the same speed as I, settling smoothly in strange, pulsating waves. Someone has sprinkled the road with salt. A car has gone off the road down a small slope and come to a halt at a lone apple tree. Some youngsters

and a couple of farmers think it could be pulled back onto the road, but human force can't possibly accomplish that. We give it one symbolic tug.

Resolution: over Burgfelden instead of over Zillhausen. Snow falls in dense flakes without any wind, which is fine. Uphill to Burgfelden it's more and more like a fairy tale, enormous beeches joined together to form a roof, everything snowy and ever so desolate. Two elderly farmers gave me some lemonade, since their only cow hadn't given much milk. Resolution: to take the footpath over the Schalksburg. What a trail! First across a field in knee-deep snow, no path recognizable, then everything tapers down to a narrow ridge, the path now clearly visible. Traces of deer. Trees and bushes seem completely unreal, with even the thinnest twigs cloaked in fluffy snow. The mist disintegrates, grey and black a village sits way below. Then sharply down through the woods directly toward Frommern. Lower down it gets wetter, ugly, cold but no more snow, and damp grass appears. Balingen, Frommern, all a meaningless loathsomeness compared with the footpath over the heights.

Rosswangen, a rest at a bus stop. A child walks past with a milk bucket, looking me over with such self-assurance that I dare not resist her gaze.

Then snow, snow, rainy snow, snowy rain; I curse Creation. What for? I'm so utterly soaked that I avoid people by crossing the sodden meadows, in order to save myself from facing them. Confronting the villages I stand ashamed. Confronting the children I change my face to look like one of the community. In a forest near a swath I force open a woodcutter's wagon. There's no beer inside, just disarray, plastic helmets, protective goggles, and barrels of corrosive liquid, the latter compelling me to open the window to breathe. The whole place is much too small for sleeping.

Tailfingen—Pfeffingen—Burgfelden—Schalksburg—Duerrwangen—Frommern—Rosswangen—Dotternhausen—Dormettingen—Dautmergen—Täbingen—Gösslingen—Irstingen—Thalhausen—Herrenzimmern—Bösingen. Now and then I turn my jacket pockets inside out, wringing out the water as I would from a wet towel. In Irstingen there was a wedding at the tavern. Greyness and Blackness and storm clouds oppress the country.

The snow lies wet on the fields, darkness comes, all lies barren, no village, no man, no hideout. At the Herrenzimmern inn it says something about lodging, but the table for the regulars is occupied, and the rest of the inn downstairs is otherwise empty. Behind the counter a pimply paleface approximately my age. I ask about spending the night, and he studies me first from head to toe. He cut himself shaving in the morning; he's so pimpled that out of politeness I look only at his hands. He says he'll have to ask first, giving his negative judgment a head start from beyond the door. Everything's taken, he says coming in, whereas everything's free. The regulars seem to side with him in not giving someone like me a room; who knows if he has any money, a sheepishly dull face exclaims. I'm too soaked to think this through.

In Bösingen I'm put up in a private home; two women, a grandmother and her daughter, take me to heart immediately, and that does me good. I get peppermint tea, fried eggs, and a hot bath. The television weather forecast says that during the course of the day tomorrow things will improve. The older woman manufactures pink brassieres at home, a

whole heap of them is piled up in the kitchen. I wanted to sit with her and watch, but I'm too tired.

Along the way I'd picked up some scraps of paper from the ground, the middle section of a pornographic magazine that someone had torn to shreds. I try to recreate how the pictures might have looked, where an arm belongs, for instance, or where the tangled limbs go. It's striking how the women, though naked, are wearing loads of cheap jewelery. One woman is blonde, the man has bad fingernails, the rest just snippets of genitalia.

Sunday 1 December

An almost toothless cat howls at the window, outside it's overcast and rainy. This is the First Sunday in Advent, and in less than three days I can reach the Rhine.

For the first time some sunshine, and I thought to myself this will do you good, but now my shadow was lurking beside me and, because I was heading west, it was often in front of me as well. At noon, my shadow, It cowered there, creepingly, down around my legs, causing me in truth such anxiety. The snow has smothered a car, it was flat as a book, this car. Much of the snow melted during the night, leaving large patches lying about, and further up the hill a shroud of snow has formed. Vast open country, rolling hills with scattered woods in between, the fields somewhat brownish again. Hares, pheasants. One pheasant behaved like a madman: it danced, spun about, uttered strange sounds, but no mate would it woo. It ignored me

as if it were blind. I could have grabbed it with my hand just like that, but chose not to. Little brooks flowed down the sloping meadows over my trail. A spring spews up in the middle of a path, and further below the brook is as broad as a lake. Crows are battling for something, one of them falls into the water. In the wet meadow lies a forgotten plastic soccer ball. The tree trunks steam like living beings. On a bench past Seedorf I take a rest because of my problematical groin; I could feel it during the night, but didn't know how to position my leg. Spending the night cost twelve marks, including breakfast. Felled trees assume a silver sheen in the light, they're steaming. Greenfinches, buzzards. The buzzards have accompanied me all the way from Munich.

Monday 2 December

Bösingen—Seedorf—Sulgen—Schramberg—
Hohenschramberg—Gedächtnishaus—Hornberg—
Gutach.

In Schramberg, things seemed to be still in order:
fried goose at the tavern, card players playing skat.
One of them would get up when he lost, pacing
back and forth among the tables with extreme agi-
tation. A climb up to the fortress instead of down,
then along the chain of hills to the Lauterbach
Valley. Black Forest farms come into view without
warning, and a completely different dialect, also
without warning. I've probably made several wrong
decisions in a row concerning my route and, in
hindsight, this has led me to the right course.
What's really bad is that after acknowledging a
wrong decision, I don't have the nerve to turn back,
since I'd rather correct myself with another wrong
decision. But I'm following a direct imaginary line,
anyway, which is, however, not always possible, and

so the detours are not very great . . . The forest
opened into an elevated valley, then past the last
farmhouse it climbed steeply through wet snow
to the Gedächtnishaus, reaching the road again
beyond the height. An elderly woman gathering
wood, plump and impoverished, tells me about her
children one by one, when they were born, when
they died. When she becomes aware that I want
to go on, she talks three times as fast, shortening
destinies, skipping the deaths of three children
although adding them later on, unwilling to let even
one fate slip away—and this in a dialect that makes
it hard for me to follow what she is saying. After
the demise of an entire generation of offspring, she
would speak no more about herself except to say
that she gathers wood, every day; I should have
stayed longer.

   Limping down, I overtook a limping man. The
road down to Hornberg is steep and I'm sensitive
about my knee and Achilles tendon. The tendon is
swollen near the top of my heel and feels as if it's
crammed into a case. In the darkness I shook the
door of a lighted stable, two aged women were milk-
ing cows, also there are two girls, five and ten years

old. The older girl was quite upset at first because she was sure, as was later revealed, that I was a robber. But soon she grew trustful, and made me tell her about the jungle, about snakes and elephants. She would probe me with trick questions, to see whether or not I was telling the truth. The kitchen is shabby, the conditions depressing, but without much thought the two women have given me a corner to spend the night. One of them wondered what had become of TV-Freddy, who used to sing so beautifully, and whose guitar was his only friend. A little jet-black cat is here, with a tiny white spot on the tip of her tail, and she's trying to catch the flies on the walls. The older girl is learning quantitative maths. I hand her my knife for the night, just in case I turn out to be a robber after all.

Through the Prech Valley, steep climb, hardly any cars, the sky glooms through veils of fog, dampness hovers in the air. Higher and higher up. Brown bracken sticks to the ground, bent down. Lofty woodland and deep, vaporous valleys. The clouds and the fog, they snub you. Water from the melting snow trickles everywhere as up on the summit I walk among the clouds, stones dripping all around.

The eye is inevitably drawn to empty forms, to boxes, refuse. My feet keep going. Elzach, telephone call; shall I turn back?

First I ate a roll by a fountain and reflected on whether I had to return. A woman and girl were observing me from behind a curtain and used a parakeet cage for additional cover. I stared back so unabashed that they fled. I won't turn back, I'm going on. Biederbachtal, a pretty little river valley sloping slightly skyward, meadows, willow stumps, beautiful Black Forest homes; above Oberprechtal there's a beautiful, functioning mill with a waterwheel, just like in the first-grade reader.

A ladies' bicycle, nearly brand new, was thrown into a brook; it occupied my thoughts for quite some time. A crime? The scene of a fight? Something provincial-sultry-dramatic has taken place here, I suspect. A bench painted red is half-covered with water. A cat has jumped up on the lantern above the front door of a house and doesn't dare move any further, feeling that she is too high above the ground. She gently sways with the lantern in the wind. The recent storm, so the newspaper says, had hurricane winds of up to one hundred miles per

hour in the Swabian Alb and peak gusts exceeding eighty miles per hour on the Feldberg. Now it's much milder, veiled by clouds, like late autumn, wet, dripping water everywhere, drooping clouds, sticky grass. I saw pigs beneath some apple trees, no grass there any more, just a swamp, and the gigantic mother sows very carefully lifted one foot from the sloshy morass, then set it very softly back again and sank on their bellies as before. I quench my thirst by drinking from rivulets that flow across the meadows. Left turn in Biederbach, therefore westward; later somehow over the mountains. 1:30 p.m.

When I ask for directions a man, a jolly farmer, tells me to come along with him on his tractor, as he's heading up that way for a while. I continue climbing in the misty woods all the way up to the Huehnersedel summit. One should be able to have a good view from there, yet there's nothing more than a theatrical towering of clouds. Descending through the lonely forest, toppled fir trees all across my path, their limbs dripping wet. At the border of the clouds below, suddenly open fields, a valley; the hills become flatter and flatter, and I can see that I've basically made my way through the Black Forest.

Melancholy clouds from the west, yet I'm invaded by a delicious feeling, except for my mouth, which is once more caked by thirst. Dusky desolation in the forest solitude, deathly still, only the wind is stirring. Below toward the west, the sky is an orangey-yellowish hue, glooming as it would before a hailstorm, while further up it is foggy-grey and black. Suddenly a huge red quarry: from above I can see a crater, at the very bottom an excavator in the red water, rusting, useless. Beside it is a rusting truck.

No one, not a soul, intimidating stillness. Uncannily, though, in the midst of all this, a fire is blazing, lit, in fact, with petrol. It's flickering, a ghostly fire, wind. On the orange-colored plain below I can see sheets of rain, and the annunciation of the end of the world is glowing on the horizon, glimmering there. A train races through the land and penetrates the mountain range. Its wheels are glowing. One car erupts in flames. The train stops, men try to extinguish it, but the car can no longer be extinguished. They decide to move on, to hasten, to race. The train moves, it moves into fathomless space,

unwavering. In the pitch-blackness of the universe
the wheels are glowing, the lone car is glowing.
Unimaginable stellar catastrophes take place,
entire worlds collapse into a single point. Light can
no longer escape, even the profoundest blackness
would seem like light and the silence would seem
like thunder. The universe is filled with Nothing, it
is the Yawning Black Void. Systems of Milky Ways
have condensed into Un-stars. Utter blissfulness is
spreading, and out of utter blissfulness now springs
the Absurdity. This is the situation. A dense cloud
of flies and a plague of horseflies swirl around my
head, so I'm forced to flail about with my arms, yet
they pursue me bloodthirstily nevertheless. How
can I go shopping? They'll throw me out of the
supermarket, along with the insect plague swarm-
ing around my head. A flash of lightning bolts
across the orange-black sky far below me, striking
Francis the Miller, of all people, dead. He whose
only friend was Stormy Joe. Francis the Miller has
passed away the years in a wooden shack on the roof
of the farm, as Francis's wife was having an affair
with Stormy Joe down in the house. They nailed

him in with boards and he didn't resist, since they'd bring him soup to eat.

Is the Loneliness good? Yes, it is. There are only dramatic vistas ahead. The festering Rankness, meanwhile, gathers once again at the sea.

Tuesday 3 December

Difficulties in finding a place to spend the night.
When I tried to break into a house in the dark,
without noticing it I lost the compass that was on
my belt; I've been attached to it ever since the
Sahara and it's a painful loss. Up on the summit,
toward evening, I met a group of men at the edge
of the forest who were waiting, strangely frozen,
with their backs to me; chainsaws were still work-
ing in the woods though it had long been quitting
time. As I approached them I could see they were
convicts consigned to forestry detail; they were
waiting for their transportation. A guard was with
them, all in green. I was overtaken later by several
barred VW vans.

I sit by the Rhine, ferry across near Kappel, calm
waters, calm weather, scarcely any people. It's hazy,
I can't see the Vosges Mountains. During the night
I slept in Münchweier, in a barn in the middle of
the village with a little straw left only up on top,

which had been stored there, however, for at least
a decade. It was dusty, you could hardly fluff it up, a
lousy place to sleep. There was no one in the house
in front, but later somebody came, opened up,
fetching something from below me. By listening
closely I could tell for sure that the person was old,
that it was a man, a man over seventy, and that
what he was fetching was wood.

Many, many ravens flying south. The cattle keep
stamping during transport, they are restless. The
Rhine seems to me like the Nanay, although there's
absolutely nothing at all that could remind some-
one of the Nanay. I wish the ferry had taken longer
coming over from the other shore, as a crossing
such as this is meant for man to fully digest. With
me are three or four cars, the water is light brown,
no other ships in sight. The towns here are asleep,
but they're not dead. Called M, troubles. I think a
lot about Deleau, Dembo, Wintrebert, and Claude.
I got the new number for Mme Eisner. Missing:
compass, flashlight battery, ointment, otherwise all
is well. Very warm; sparrows and children in Boof-
zheim. I say Thirst. Bought milk in a shop, the sec-
ond quart today. The children here sneak into the

corner shops and grab the comics, which they proceed to read quickly while crouching in a corner where the convex mirror of the shopkeeper can't find them. I get drunk on milk. Cocks are crowing, doors slam, sunshine, I rest on a bench in front of the church.

Flat countryside, only the crows, shrieking all around me—I suddenly ask myself seriously whether I've lost my mind, as I hear so many crows but see so few. There is dead silence around me, as far as I can hear, and then there's the shrieking of crows. Mistily the heights of the Vosges Mountains are penciled along the horizon. On the plain below, two amusement parks: ferris wheels, a haunted house ride, a medieval castle, utterly deserted and closed down. It looks permanent. In the second one there was also a zoo, a pond with geese, to the rear a pen with roebucks. Somebody's driving a load of hay on a tractor. The war memorials are my resting place. The farmers' wives talk a lot to each other. The farmers themselves are dead tired. I'm always seeing empty buses. All right, I say, keep it going.

In Bonfeld there were kindergarten kids around me who took me for a Frenchman. Finding a place

to spend the night will be difficult. On the final
stretch to Barr, a few kilometers out, a woman
picked me up in her car; I had no qualms in accept-
ing the lift since it gave me the chance to buy a
compass before the shops closed. The compass is
hydraulic, but it doesn't have my friendship yet.
Among the bald bare poles of the Stangen Woods,
workmen have hacked off branches and built a fire,
bundling all the twigs as well. The ravens continue
shrieking around my head here in this town. For
the first time, no pains in the legs beyond my
fatigue, although now and then, perhaps, there's
the left knee. The right Achilles tendon doesn't
seem too critical any more, since I've padded the
place where the back of the boot bends inward with
all the foam I had and laced the boot carefully. I
have to wash my shirt and woolen jersey today, they
both reek so strongly of me that I have to zip up my
jacket whenever I'm among people. The turnover
of liquids is very high: today two quarts of milk, a
pound of tangerines, and shortly thereafter I was so
thirsty again that my spittle was sticky, thick, and
white as snow. When I approach people I wipe the
corners of my mouth, because I have a feeling that

there's foam on them. I spat into the River Ill, and the saliva floated away like a solid cotton ball. At times the thirst is so great that I can think only in terms of thirst: the farmhouse there at the end of the road must surely have a well; why is this pub closed today, a Tuesday, when I need a beer or Coke so badly? Tonight I shall wash the jersey, the tricot that Nuber from the Offenbach Kickers was wearing during his farewell game. I might walk along the River Aube, I heard somewhere the Aube is good. The wit of the people here stems from settling in one place for a thousand years. I have a feeling it's better that Alsace belongs to France.

A pile of garbage on the plain truly distracts me; I saw it from a distance and walked faster and faster, eventually as if I were seized with mortal terror, because I didn't want to risk being passed by a car before I'd reached it. Gasping from the mad race I reached the mountain of garbage and needed quite a long time to recover from all this although the first car passed me several minutes after I'd arrived. Close by was a ditch with dirty, cold water and a wrecked car with doors, hood, and trunk wide open. The water reached up to the windows and the

engine was missing. I see ever so many mice. No one has the vaguest idea just how many mice there are in the world, it's unimaginable. The mice rustle very lightly in the flattened grass. Only he who walks sees these mice. Across the fields, where the snow lay, they've dug tunnels between grass and snow; now that the snow's gone the serpentine traces still remain. Friendship is possible with mice.

In a village before Stotzheim I sat on the steps of a church, my feet were so tired and a sorrow was gnawing at my chest; then a window opened in the schoolhouse next door, a child was opening it following orders from inside, and then I overheard a young teacher scream so harshly at the children that I hoped no one would notice that a witness to these terrifying screams was sitting below the window. I went away, although I could hardly put one foot in front of the other. I headed toward a fire, a fire that kept burning in front of me like a glimmering wall. It was a fire of frost, one that brings on Coldness, not Heat, one that makes water turn immediately into ice. The firethought of ice creates the ice as swiftly as thought. Siberia was created in precisely this manner, and the Northern Lights represent its

final flickering. That is the Explanation. Certain radio signals seem to confirm this, especially the intermission signals. Likewise at the end of the daily television programming, when the set buzzes and the screen is filled with snowy dots, implying the same thing. Now the order of the day is: all ashtrays must be put in place and self-control maintained! Men discuss the Hunt. The waitress dries the silverware. A church is painted on the plate, from the left a path is leading up, very sedately a costumed woman is moving there and next to her, with her back to me, a girl. I disappear with the two of them into the church. At a corner table a child is doing his homework, and often the beer is called Mutzig. The innkeeper cut his thumb days ago.

An immaculately clear, cool morning. Everything is hazy on the plain, but one can hear life down there. The mountains, full and distinct in front of me, some elevated fog, and, in between, a cool daytime moon, only half-visible, opposite the sun. I walk straight between sun and moon. How exhilarating. Vineyards, sparrows, everything's so fresh. The night was pretty bad, no sleep from three o'clock on; in the morning, making up for it, the boots have lost their painful places and the legs are in order. The cool smoke of a factory rises calmly and vertically. Do I hear ravens? Yes, and dogs as well.

Mittelbergheim, Andlau. All around the ultimate peace, haze, labor; at Andlau there's a small weekly market. A stone fountain, the likes of which I've never seen before, is my resting place. The wine-growers subsidize everything here and are the backbone of these villages. In the church in Andlau, the priest is singing mass, a children's choir clustered

around him, with otherwise just a few old women in attendance at the service. On a frieze outside, the most grotesque Romanesque sculptures. Holiday homes at the edge of town, all closed for the winter and shuttered up. But breaking into them would be easy nevertheless. A row of fish ponds there is exhausted, used up, overgrown with grass and brush. It runs along a brook.

A perfect morning; in perfect harmony with myself I'm walking briskly uphill. The potent thoughts of ski jumping make me feel light, like floating on air. Everywhere honey, beehives, and securely locked holiday homes throughout the valley. I chose the most beautiful one and contemplated breaking in then and there to stay the entire day, but it was too nice walking, so I walked. For once I didn't notice that I was walking, all the way up to the mountaintop forest I was absorbed in deep thought. Perfect clarity and freshness in the air, up further there's some snow. The tangerines make me completely euphoric.

Crossroads. Badly marked from here on. Naked woodland swaths with blue smoke all about from the woodcutters' campfires. As fresh as before and,

like this morning, dew on the grass. Practically no cars up to now, and just half of the houses are inhabited. A jet-black wolfhound glared after me with his yellow eyes unflinchingly. When a rustling came from some flying leaves behind me I knew it was the dog, even though it was chained. All day long the most perfect solitude. A clear wind makes the trees up there rustle, the gaze travels very far. This is a season that has nothing to do with this world any more. Big flying reptiles soundlessly leave their vapor trails behind above me, heading directly west, flying via Paris as my thoughts fly with them. So many dogs, from the car one doesn't notice them that much, the smell of the fires, too, the Sighing Trees. A shaved tree trunk is sweating water, again my shadow cowers far in front of me. Bruno flees, at night he breaks into an abandoned ski-lift station, it must be in November. He pulls the main lever for the cable car. All night long the ski-lift runs nonsensically, and the entire stretch is illuminated. In the morning the police seize Bruno. This is how the story must end.

Higher and higher, I've almost reached the snow-line that begins at about 2,600 feet, and then, fur-

ther up, the border of the clouds. Foggy wetness begins, it grows dusky and the path ends. I inquire at a farmhouse, the farmer says yes, I'd have to go up through the snow and a beech forest, then I'd certainly come upon the road Le Champ du Feu. The snow is half-melted, hardly any footprints, at last they stop altogether. The forest is foggy-wet, I know it will be unpleasant beyond that height. The farm was called Kaelberhuette, it's deathly still in the cloudy mist. It is impossible to know where you are here, only your direction is known. Although I've apparently attained the summit, when I don't reach the road it strikes me as odd, and I stop in the dense woodland that finally consists of fir trees; thick fog has settled all around me. I try to work out where I made a mistake. There's no other solution possible than heading further west. As I pocket the map, it occurs to me that there's garbage strewn about in the woods, an empty can of motor oil and other things that could only have been thrown from cars. Then it turns out that the road lies only thirty meters away from me, but I can see only as far as twenty meters, and clearly, just a few steps. Following the road northward in the thickest fog I hit a

strange circular outpost, with an observation tower
in the center resembling a lighthouse. Stormy
winds, intense wet fog, I take out my storm cap and
talk out loud, since all of this is barely believable
after such a morning. Now and then I can see three
white lines on the road in front of me, never any
further, sometimes just the closest one. The big
decision: follow the road north or south? It later
turns out that both ways would have been correct,
because I had been walking westward between the
two little roads. One leads over Bellefosse to Fou-
day, the other down to Belmont. Steep slopes and
slashing wind, empty ski-lifts. I can hardly see
my hand before my face; this is no proverb, I can
scarcely see it. Hath this brood of adders venom?
Aye, thou speakest sweet, whilst thou are wicked
withal. I yearned to kindle a fire; I would love noth-
ing more than to see it already ablaze. 'Twould fill
mine heart with dread lest thou break salt unto me.
Meanwhile it's got stormy, the tattered fog even
thicker, chasing across my path. Three people are
sitting in a glassy tourist café between clouds and
clouds, protected by glass from all sides. Since I
don't see any waiters, it crosses my mind that

corpses have been sitting there for weeks, statu-
esque. All this time the café has been unattended,
for sure. Just how long have they been sitting here,
petrified like this? Belmont, a Nothing of a prov-
ince. The road was thirty-five hundred feet high,
leading down now snake-like by a brook. Lumber-
jacks again, smoking fires again, then at 2,300 feet
the clouds suddenly blow away, yet below them a
cheerless drizzle starts to fall. All is grey, devoid of
people; downhill beside a damp forest. At Walders-
bach no chance of breaking into anything, so I
accelerate, to find some shelter in Fouday before
nightfall. As there are hardly any possibilities even
there, I decided to force open a tavern that's locked
on all sides, a big one in the center of town between
two inhabited houses. Then a woman came, didn't
say a word and stared at me, so I didn't do it.

Outside town I go to eat at a truck stop, and a
young couple with something strange and oppres-
sive lurking about them, as in a Western, enters the
restaurant. At the next table a man has fallen asleep
over his red wine, or is he faking sleep and lurking
as well? The little duffel bag I've carried most of the
time over my left shoulder, and which rests on my

hip, has worn a fist-sized hole into the sweater under my jacket. I've barely eaten anything all day, just tangerines, some chocolate, water from streams drunk in animal posture. The meal must be ready by now; there will be rabbit and soup. At an airport, a mayor has been beheaded by a helicopter as he was stepping off. A truck driver with lurking eyes, wearing worn-out slippers, pulls out an extremely misshapen Gauloise and smokes it now without straightening it out. Because I'm so lonely, the stout waitress lends me an inquisitive word over the lurking silence of the men. The exposed root of the philodendron in the corner has sought tentative support in the radio loudspeaker there. A small porcelain Indian figurine is also standing there, his right hand lifted toward the sun, his left hand supporting the arm that's pointing up: it's a stately little statue. In Strasbourg, films by Helvio Soto and Sanjines are showing two or three years late, but showing nevertheless. Someone at a table near the counter is called Kaspar. A word at last, a name!

Searching below Fouday for a place to spend the night, it was already densely dark and damp and cold. My feet aren't working any more, either. I

break into an empty house, more by force than cunning, although another house that's inhabited is right nearby. In this one workers seem to be repairing something. Outside a storm is raging as I sit in the kitchen like an outlaw, burnt out, tired and drained of all sense, because only here is there a wooden shutter that allows me to switch on a little light without the glow escaping outside. I'll sleep in the nursery since it's the best place to flee from, in case somebody living here does in fact come home. Most surely there will be workmen coming early in the morning, with the floors and walls in some rooms being redone, and the workmen having left behind their tools, shoes, and jackets overnight. I get drunk on some wine that I bought at the truck stop. Out of sheer loneliness my voice wouldn't work so I merely squeaked; I couldn't find the correct pitch for speaking and felt embarrassed. I quickly split. Oh, what howling and whistling around the house, how the trees are jeering. Tomorrow I have to get up very early, before the men arrive. In order to wake up by the morning light, I'll have to leave the outside shutter open, which is risky because the broken window will be

visible. I've shaken the glass splinters from the blanket; adjacent is a crib, plus toys and a chamber pot. All of this is senseless beyond description. Let them find me here, sleeping in this bed, those feeble-minded masons. How the wind outside is worrying the forest.

Around three o'clock I got up in the night and went out to the little porch. Outside there was a storm and heavy clouds, a mysterious and artificial sort of scenery. Behind a stretch of countryside, the faint glow of Fouday was glimmering strangely. A sense of utter absurdity. Is our Eisner still alive?

Thursday 5 December

Set out very early in the morning. The alarm clock
I'd found ticked so treacherously loud in the house
I left behind that I climbed back inside, retrieved
it, and threw it a bit further away into some under-
growth. Right after Fouday the most awful down-
pour began, rain mixed with hail, the black clouds
threatening evil. I took shelter under a tree in the
lingering morning gloom. Below me the road, and
beyond the brook some railway tracks. It's so dismal.
A little further it really gets serious. I crouched
above the road beneath the fir trees, my poncho
drawn around me, but that hardly helps any more.
Trucks are humming past without seeing me, the
animal, under the branches. A multicolored trail of
oxidized diesel runs uphill. A very intense down-
pour. I pretend to blend into the forest. Then a
farmer on a moped tried to figure me out. He
stopped short, looked at me oddly, and said, "Mon-
sieur," nothing more. When I gaze on the fir trees,

how they sway into each other, worried by the
storm into slow-motion trembling and grinding
movements, I get dizzy; a single glance is all it
takes, and suddenly I'm about to faint in the middle
of the road. An orchestra appears but doesn't play,
although it is haplessly entrapped with the audience
in a discussion about the Decline of Music. There
is a long table and a musician has taken a seat up
front. He is utterly absentminded, running his fin-
gers through his hair so peculiarly and pathetically
that my urge to laugh becomes so strong my stom-
ach aches. A rainbow before me all at once fills me
with the greatest confidence. What a sign it is, over
and in front of him who walks. Everyone should
Walk.

Memorial plaques in La Petite-Raon for those
deported by the Gestapo—196 people, who com-
prised at least half the village. For quite some time
I studied the plaques without realizing that from a
stairway close by a young woman was studying me.
If the village hall had been open I would have asked
what had happened there.

In Senones there is an incredible church. In
the café opposite there were voices; I went there,

ordered coffee and a sandwich; surrounding me
the youthful village loiterers lounged. One of them
played pool so poorly that he cheated, even though
he was alone. A timid Algerian who was at the table
with me didn't dare to order, because he couldn't
understand the menu. In front of the café a brand
new Citroen is parked with a huge load of hay
strapped to the roof.

In Raon l'Étape I debated for a long time
whether or not it made sense to walk on, as it
would be at least twelve miles to the next town,
with everything here being so drawn out. A small
hotel, pretty outside, decided the question: I have
to wash myself properly again. Called Munich at
the post office. This time the news was somewhat
better. The last stretch here one big truck fol-
lowed another, which caused me great anxiety.
The entrance to town near the railway line and
a paper mill didn't seem so inviting at first, but
toward the center of town the oppressive feeling
dwindled. Four youths in a bar are playing table
soccer with a brute force I've never seen before.
The voices are loud here, but loud in an agreeable
way. Martje says there was a storm, there was hail,

and she wanted to roast apples. The heels on my
shoes have obviously worn out although the soles
are solid; the hole in the sweater from the duffel
bag is getting bigger. Today, especially en route
to Senones, I felt severe despair. Long dialogues
with myself and imaginary persons. Still some low,
drooping clouds over the hills. The hills are getting
lower; what choice do they have, anyway? I must be
careful with my right Achilles tendon, still swollen
twice its size though it doesn't feel so alarmingly
inflamed any more. A boy here with a broad para-
trooper's strap for a belt around his waist, which is
meant to lend him a particularly tough appearance,
sticks a match between his teeth with exceptional
coolness and sits down between two flustered,
pubescent girls. One of them has painted her
fingernails a rich pale blue. A woman here has
nothing but gold teeth. Deducing from the ashtray,
somebody before me had been smoking. I prepare a
few French sentences. Tomorrow, if it doesn't rain,
perhaps I'll walk thirty-five miles, for once.

Friday 6 December

The chairs in the restaurant were still standing
on the tables, but I was served breakfast graciously
nonetheless. Beside me in the restaurant, which
was otherwise empty but for two cleaning women,
the waitress was taking breakfast, and together we
looked in the same direction, the direction of the
street. I wanted to look over at her, but neither of
us dared direct our gaze at one another, for due to
a secret, compelling reason this wasn't allowed. I'm
sure she was under the same compelling urge. She
stared rigidly ahead, the urge urged us both. I stood
in line outside some sort of kiosk at the street cor-
ner, I can see the kiosk in front of me. I stood in
line to buy enough film for a whole feature film; it
was Saturday, just before closing time at five o'clock
in the afternoon, and I wanted to shoot the entire
film on Sunday. The kiosk had all sorts of things,
licorice, too. All of a sudden, the fat guy inside with
the turtleneck sweater puts up the shutters, pre-
cisely at five o'clock, closing down right before my

very eyes, though I've been waiting in line, and he could see that I've been standing there for at least half an hour. And I do need all those Kodak boxes he has stored in his stall. So at once I went to the side door of the kiosk, which is so tiny that one person can barely stand upright in it. I don't want a piece of licorice, I said, I want all the film you have inside with you. Then the guy stepped out, leaned against the wall of the house next door, and said, "It's five o'clock now, I'm closed." With each word he made such an overdone, unheard-of, unreal gesture overhead that immediately it became clear to me that I'd have time enough to buy the film on Monday. "Good," I said, gesticulating with the same ghastly gestures myself, "then I'll come on Monday." Both of us made the ghastliest gestures to show what we thought of each other, and parted company.

Rambervillers. As I walk the word *millet,* which I've always liked so much, just won't leave my mind, the word *lusty* as well. Finding a connection between the two words becomes torture. To walk lustily works, and to reap millet with a sickle also works. But millet and lusty together doesn't work.

A dense woodland unfailingly comes to pass. Atop
the peak of a mountain pass two trucks converge,
the cockpits coming so close that one driver can
climb over to the other one without touching the
ground. Together, never speaking a word to each
other, they eat their lunch. They've been doing this
for twelve years, always on the same route, always
at the same place, the words are exhausted but the
food can be bought. The forest slowly ends here, the
fierce hills, too. For many, many miles, uninhabited
woods sprawl all around, woods that served as bat-
tlegrounds in the First and Second World Wars.
The countryside becomes more open and spacious.
An irresolute rain drizzles down, staying at a rate
where it doesn't matter much. My output of sweat
is prodigious, as I march lustily thinking of millet.
Everything's grey on grey. Cows loom astonished.
During the worst snowstorm on the Swabian Alb,
I encountered a provisional enclosure for sheep,
the sheep freezing and confused, looking at me
and cuddling against me as if I could offer a solu-
tion, The Solution. I've never seen such expressions
of trust as I found on the faces of those sheep in
the snow.

Rain, rain, rain, rain, rain, only rain, I can't
recall anything more. It's become a steady, even
drizzle, and the road becomes endless. No one's in
the fields, an endless stretch through a forest. From
their cars people have freed themselves of every-
thing superfluous: there lies a lady's shoe, a suitcase
over there—small but probably full, I didn't stop
to look—a whole stove. Three children in a village,
respectfully keeping their distance, followed a boy
carrying a water-filled plastic bag with live tropical
fish inside. Even the cows here broke into a gallop
before me.

Nomexy, Nivecourt, Charmes. A man took me in
his car the last few miles, but after a short distance
I switched over to a dilapidated van, in which empty
glass bottles were rolling freely about in the back.
I declined the offer of a cigarette, my body slowly
warming up and steaming from the dampness.
The windows of the car fogged up instantly from
my intense steaming, so much so that the man had
to stop to find a rag to wipe them, since he couldn't
see any more. Beside the main road to Charmes
there was an exhibition of campers and mobile
homes, which, now that it's wintertime, were lying

lonely and forsaken behind a chain-link fence. Only in one of them was there furniture and a bed, it being the showpiece of the exhibition, a huge thing right at the roadside, where the trucks always have to stop for a red light. It was elevated, as well, on a wooden platform. All the others further back were utterly bare inside, yet in the showpiece there was even a refrigerator and a bed with a bedspread, decorated with silken frills and lace. During a brief moment while no cars were stopping at the traffic light, I broke open the showpiece with a single jerk. When I went toward the bed, the entire trailer suddenly swung down like a seesaw in a children's playground, standing slightly lopsided, the front end pointing skyward. It was supported only at the front and in the middle, not behind the bed. I was frightened and a truck driver outside at the light could see this, too. He drove a bit slower, glanced over, but, giving me a look of complete incomprehension, drove on.

Before going to sleep, I took a stroll into town on my still-sizzling soles. There was a procession with brass bands, cherry bombs, and little girls marching in parade, plus parents, children, and, behind them

all, a float being towed by a tractor. On top of the float, which was surrounded by torch-bearing members of the volunteer fire brigade, Santa Claus stood tossing candy from a cardboard box among the children, who flew after it with such abandon that a couple of boys, diving headlong for some sweets that had been flung too far, crashed hard against a closed door. Santa looked so moonstruck that I almost suffered a stroke. His face is barely visible for the cotton mop of a beard, with the rest hidden by black sunglasses. About a thousand people gathered in front of the town hall, and Santa Claus sent his greetings down from a balcony. Shortly before this, the tractor had run into the wall of a house by mistake. Boys threw firecrackers between the legs of the uniformed girls, who broke ranks and scattered in all directions, regrouping in the lavatory of a nearby bistro to pee. When Santa appeared with his sunglasses up on the balcony, I was completely convulsed by a paroxysm of laughter. A few people gave me strange looks and I retreated to the bistro. While eating my sandwich I ate one end of my scarf as well, which cracked me up so much inside that the whole table started to shake, though outwardly

my face gave no signs of laughter, however con-
torted it must have been. The waiter started star-
ing at me, so I fled to the edge of the town into the
camper, into the showpiece. My right foot doesn't
look too good from the long march today. The
Achilles tendon is rather irritated and remains
twice its proper size, also a swelling around the
ankle, probably because I'd been walking all day
long on the left side of the asphalt road, thereby
making the left foot tread level ground, whereas the
right didn't really tread level ground since the road
sloped a bit to let the rainwater flow down, and so it
twisted a little with every step. Tomorrow I'll make
myself switch roadsides now and then. As long as I
walked criss-cross I didn't notice a thing. The soles
burn from the red-hot core in the earth's interior.
The loneliness is deeper than usual today. I'm devel-
oping a dialogical rapport with myself. Rain can
leave a person blind.

Saturday 7 December

I immediately pulled the covers of my display bed over my ears when I saw how hard it was raining outside. Please, not this again! Can the sun be losing every consecutive battle? It wasn't until eight in the morning that I finally set out again, already completely demoralized at that early hour. A merciless rain and humidity, and the profoundest desolation pressed down upon the land. Hills, fields, morass, December sadness.

Mirecourt, from there onward in the direction of Neufchâteau. There was a lot of traffic and then it really began to rain, Total Rain, a lasting-forever winter rain that demoralized me even more because of its coldness, so unfriendly and all-penetrating. After a few miles someone gave me a lift; it was the driver who asked if I'd like to hop in. Yes, I said, I would. For the first time in quite a while I chewed a piece of gum, which the man gave me. That bolstered my self-confidence for a bit. I rode with him more than twenty-five miles, then a stubborn pride

arose in me and I went on in the rain. Rain-draped landscape. Grand is just a beggarly village, but it does have a Roman amphitheater. At Châtenois, which was capital of the whole region during the time of Charlemagne, there is a fairly large furniture factory. The citizenry here is very excited because the factory owner abandoned the place by night, leaving things directionless and devoid of instructions. Nobody knows where he fled to, and they have even less understanding why. The books are in order, the finances intact, but the factory owner's fled without a word.

I walked, walked, walked, walked. A beautiful fortress with fine, ivy-veiled walls stood in the distance. Even the cows were wondering about the fortress, not about me. Broad trees offered shade from the heat, and the water that trickled down everywhere was good against the sun. At the seashore below there were massive, dead ships sitting motionless. At the fortress there were only white creatures: white hares, white doves, and even the goldfish in the crystal ponds are white. And then the Incredible: the peacocks are white, they're albinos, like snow, their eyes light red. A peacock spreads its white wheel, and other peacocks sit

screeching in the trees, but only now and then do they mingle their shrieking voices with the shrieking rain. I want to head a bit northward to Domrémy, the house where Joan of Arc was born—that I'd like to see. Wet woods alongside streams. I haven't seen any coal. I hear there's a lot of furious fighting in all the cafés.

The dreariest possible route toward Domrémy, I can't tell if my course is correct anymore, I let myself drift. A falling forward becomes a Walk. Strong rain at first, then only misty drizzle later. Slowly and drearily flows the River Meuse beside me. The old railway just below the river is no longer in use, with the new one running further up to the right, beyond the road. At a deserted gatekeeper's hut I couldn't go on anymore. There's no roof, no windows, no door. Up on the road the cars are moving through the rain; further up, a freight train. The second-story floor keeps the rain out somewhat. Wallpaper with a brick pattern hangs torn in tatters on the wall, a chimney in which nettles are withering molders, some rubble on the floor. Remnants of a double bed, metal bedsprings, but still I'm able to sit on one end. Birds nesting all round

in the thorny, rain-drenched bushes. The railway
tracks are rusting. The wind blows through the
house. The rainy mist hovers in the air like a solid
object. There are glass fragments, a crushed rat,
and there are red berries on a wet, bare bush in
front of the open door. For the blackbirds it is once
more the time before the advent of the first men
in this land. No one is in the fields, absolutely no
one. The thin plastic poncho rustles in the win-
dow frame so that it doesn't rain too much inside.
There's no sound at all from the river, it's slow and
soundless. Neglected grass sways wilting in the wet
wind. A decaying staircase leads up to the first floor,
but it will break once I step on it. Delivery trucks
are outside in the rain. Where a flower bed had
been in front of the house, now there are bushes
and wild grass; where a fence had been, now there
is rusting wire. The threshold lies a step beyond
the door, wet and overgrown with yellowish algae.
I want to go on, I hope I won't meet any people.
Whenever I breathe, the breath goes out the door,
the breath drifts swiftly free.

 Harvest machinery was standing for sale by the
roadside, but there were no more farmers. A flock

of jackdaws was flying south, much higher in fact
than jackdaws normally fly. At a basilica, a bucolic
one, right nearby, an unknown Merovingian king is
buried. Out of the old grey woodland came a voice
from within.

In Coussey I crossed the Meuse, following the
small road to the left, then up to the basilica. I was
strangely moved. Such a solemn valley and such a
view as would be found in the background of the
most solemn Dutch paintings. On both sides there
are hills, the Meuse wanders through the flat valley,
the view east is beyond compare, all in December
haze. The trees along the riverside stand in misty
rain. This spot touched me, and I summoned forth
some courage once again. Directly adjacent to the
basilica stood a house I tried to break into, but I
quit because it was too securely barred, and I'd have
caused such a racket that the neighbor would have
heard something. At Domrémy I went inside Joan's
house; so this is where she comes from, it lies right
by the bridge. There is her signature, before which
I stand a long time. She signed it Jehanne, but most
likely her hand was guided.

Sunday 8 December

The land here is being carelessly killed. Children
are playing around the church. During the night
I was very cold. An old man crosses the bridge,
unaware that he's being watched. He walks so
slowly, and ponderously, pausing again and again
after short, hesitant steps; that is Death walking
with him. All is shrouded still in semi-darkness.
Low clouds, it won't be a good day. Till's wedding
took place on the mountain, which was covered
with snow, and I pushed Grandma up the moun-
tain. Erika cried down from above that we should
remain seated where we were. I said, "First of
all we're not sitting and, second, where are we
supposed to sit in this wet snow?" An athletic,
shorn sheep that had strayed onto the village road
approached me in the semi-darkness, bleating at
me, then it lapsed back into its elastic trot. Now,
as dawn approaches, the sparrows stir. The village
was sluggish yesterday, like a caterpillar in the cold.

Today, on Sunday, it's already become the chrysalis.
Because of the frost, the earthworms unable to
cross the asphalt road have burst. Underneath the
eaves of tin, where one can sit outside in the sum-
mer, loneliness is crouching now, ready to spring.

Domrémy—Greux—Les Roises—Vaudeville—
Dainville—Chassey: there's a rainy gloom low and
deep above the hills, but it's only drizzling, it won't
be so bad. Utter loneliness, a brook, and its dell
are my companions. A grey heron flies in front of
me for many miles, then settles until I come close,
when it flies further ahead again. I shall follow him
wherever he flies. The dampness invades every-
thing: jacket, trousers, face, hair. Droplets are
dangling from barren bushes. Belladonna berries,
bluish-black, have clouded over with grey from the
mist. On all the trees an ice-grey lichen is growing,
sometimes ivy as well, in the endless, dense, wildly
fecund, ice-grey woods. A chase echoes deeply in the
interior, then hunters come along the road. From a
van a pack of hounds emerges. The towns are half-
deserted, half-decrepit, all forgotten. The houses
are small, sunken in hoary heaps of moist, ice-grey
masonry.

It is slowly getting lighter, but still a dampness in the air, the landscape gloomy and grey. In Chassey a truck sucks milk from cans into its tanks. A great, lucid decisiveness about my fate surged up inside me. I shall reach the River Marne today. Cirfontaines is dying away, abandoned houses, a big tree has fallen across a roof a long time ago. Jackdaws inhabit the village. Two horses are feeding on the bark of a tree. Apples lie rotting in the wet clay soil around the trees, nobody's harvesting them. On one of the trees, which seemed from afar like the only tree left with any leaves, apples hang in mysterious clusters close to one another. There isn't a single leaf on the wet tree, just wet apples refusing to fall. I picked one, it tasted pretty sour, but the juice in it quenched my thirst. I threw the apple core against the tree, and the apples fell like rain. When the apples had grown still again, restful on the ground, I thought to myself that no one could imagine such human loneliness. It is the loneliest day, the most isolated of all. So I went and shook the tree until it was utterly bare. In the midst of the stillness the apples pummeled the ground. When it was over, a haunting stillness grabbed me and I glanced

around, but no one was there. I was alone. At an abandoned laundry I drank some water, but that was later.

I was walking on an avalanche of wet snow without initially noticing it. Suddenly the entire slope was creeping forward most peculiarly, the whole earth beneath me beginning to move. What is creeping there, what is hissing there, I said, is this some serpent hissing? Then the entire mountainside crept and hissed below me. Many people had been forced to spend the night in a stadium, and since they were sleeping almost on top of each other on steps built ever so steeply, whole human avalanches began to tumble and slide. There was no stopping for me and I ended up in a brook, a long way from Poissons, I could even tell where its source was, and so I said, this brook will bring you to the Marne. At dusk I crossed the Marne by Joinville, first across the canal, then across the river, which was flowing swiftly and muddily from the rain. In passing a house I saw that there was a ski race on the television. Where shall I sleep? A Spanish priest was reading mass in bad English. He sang in awful tones into the over-amplified microphone,

but behind him was some ivy on the stone wall, and there the sparrows were chattering, chattering so close to the microphone that one couldn't understand the priest anymore. The sparrows were amplified a hundredfold. Then a pale young girl collapsed on the steps and died. Someone daubed cool water on her lips, but she preferred Death.

Monday 9 December

Yesterday was the Second Sunday in Advent.
The latter half of yesterday's route: Cirfontaines—
Harmeville—Soulaincourt—Sailly—Noncourt—
Poissons—Joinville. In Joinville a conspiracy hovers
over everyone's head. As yet uncertain about the
route today, probably straight toward Troyes, pos-
sibly via Wassy. The cloud situation has hardly
changed since yesterday, the very same thing: rain,
gloom. Noon in Dommartin-le-Franc; I ate a little.
The countryside is boring, hilly, bare, plowed wet
fields. In the furrows cold water has gathered, at a
distance all dissolves in cloudy drizzle. It's really not
rain, just sheer drizzle. The towns are still spread
far apart, seldom a car. The walking's working. I'm
completely indifferent as to where and how far I'll
walk today.

On the other side of the road, along the rim of
a wet field, a huge dog strayed up to me, obviously
ownerless. I said *woof* to him, then he immediately

came and followed me. When I looked back at him
several times, he didn't want to be seen, and he just
trotted behind me in the roadside ditch. It went on
like this for many miles. Whenever I looked at him
he'd shrink into the ditch, stopping indecisively
with a start. The huge dog made a sheepish face.
When I walked, he walked, too. Then he vanished
unexpectedly, and though I looked for him for quite
some time, and waited a bit as well, he didn't show
up again. "Love your bed as you love yourself" was
written in chalk across the wall of a house.

For how long had there been no place good
enough for cowering down? I said "cower" to
myself. There are just harvested fields flooded with
water, and the drizzling grey clouds directly above.
Stalks of corn have sucked up too much water and
are rotting away, bent over. At the side of the road
I was startled by heaps of slippery mushrooms,
colonies the size of car tires, which looked malig-
nant, poisonous, and putrid. Horses grey with age
were standing motionless on watery meadows,
hundreds of thousands of them, forming a cordon.
Ducks in muddy farmyards. While taking a rest I
realized that sheep were staring at me fixedly from

behind. They were standing in rank and file, all of this happening near a petrol station. When the station attendant eyed me mistrustfully, the sheep moved closer in formation, such closing-in becoming so embarrassing that I acted as if my rest had ended long ago; nevertheless I was so happy with the little stone wall from which I was able to let my legs dangle a bit, at last. For the first time I saw two tractors working in a field today, far off in the distant mist. Since the Rhine Valley I haven't seen anyone in the fields. Christmas trees are being set up, without any decorations yet, just as they are. Finally the terrain became quite flat, to stay this way for a long time. The loneliness today stretched out ahead of me toward the west, though I couldn't see that far as my eyesight let me down. I saw birds rising from an empty field, increasing ever more until the sky at last was filled with them, and I saw that they were coming from the womb of the earth, from very deep down, where gravity is. That's where the potato mine is, too. The road was so endless, I was overwhelmed by fright. For the past week the rain and misty greyness have made it impossible for me even to guess the position of the sun. Upon my

arrival in Brienne, people started to hide at once,
with only a small grocery store staying open by mis-
take. Then it closed, too, and since then the town
has been deserted to death. Above this town here
sits the massive castle, enclosed by a wrought-iron
fence. That's the insane asylum. Today I often said
"forest" to myself. Truth itself wanders through
the forests.

Tuesday 10 December

Crystal clear weather for a while, a joyful feeling
upon seeing the sun, everywhere steam: steam from
the Aube as if it were boiling, steam from the fields.
When I look up to the sky while walking, without
realizing I walk on a curve toward the north. Right
after the Aube, the steam from a field was so thick
and so low above the ground that I waded through
it shoulder-high. Viewed far and wide, the land is
almost flat. A mangy woman chases a mangy dog
out of the house. Oh, my God, how I am cold, God,
please make my parents old. Burro fell from the
tenth floor because the balcony had holes that didn't
belong there, and he died immediately. The owner
of the hotel, fearful for his good reputation, and
recognizing the vastness of my pain, offered me
nineteen thousand marks for my education. Edu-
cation for what, I said, that's Judas's money, that
won't revive a soul. The road, the shortcut to Piney,
I had all to myself. Through the wall of the toolshed

in which I slept I heard somebody snore, past midnight there was a brief rumble once and I was wide awake, for an instant thinking I would flee. The houses and the people here are markedly different, but the villages have all seen better days. At a railway crossing I met an old gatekeeper who's now retired, but he goes with a rag every day to the gatekeeper's hut inhabited by his successor, and wipes off the inside of the automatic switchbox. They let him. Slowly the clouds reappear, but the birds make pleasant sounds. In Piney I bought milk and tangerines, and took a rest in the middle of town. On taking a closer look, I realized I was sitting on the mark for some triangulation point.

This stretch of road is completely straight; whenever it goes uphill, it only goes toward the clouds. Immense, empty fields; the cars are being drawn over the road as if something were sucking them in. Just past Piney I was stopped and checked by astonished patrolmen, who wouldn't believe a word I said and wanted to take me with them right away. We came to an understanding only once the city of Munich was mentioned. I said *Oktoberfest,* and one of the policemen had been there and remembered

the words *Glockenspiel* and *Marienplatz*; he could say this in German. After that they became peaceful. From far away, from a hilltop, I saw Troyes before me. Then some cranes flew over me in perfect formation. Against the strong wind they flew scarcely faster than I was moving on foot. There were twenty-four of them, big, grey, and every so often one of them gave a hoarse cry. Whenever a gust of wind upset their formation, some of them soared, while others who had been torn away from the unit fought back to their original positions; it was magnificent how they regrouped. Like the rainbow, the cranes are a metaphor for him who walks. Beyond Troyes I could see a faint ridge of hills, probably the far side of the Seine Valley. Then the cranes veered abruptly southeast, most likely toward the national park that is situated there. I bought a carton of milk before crossing the Seine, drinking it as I sat on a railing of the bridge. The empty carton that I threw into the water will be in Paris before me. I'm wondering about the smugness with which people move about. I haven't been in a big town in such a long time. I went directly to the cathedral without stopping to wonder. On throbbing feet I crept around it,

and out of pure astonishment I didn't dare go in.
I certainly wasn't part of the plan. I took a tiny
hotel room and washed out Nuber's jersey, since
it no longer reeked of Nuber in his farewell game
with the Offenbach Kickers, but of me. It's drying
on the little radiator now. The big cities hide their
dirt; there are so many fat people there as well. I
saw a fat man on a racing bike and a fat man on a
moped with his mangy dog sitting in front of him
on the petrol tank, and I bought some cheese from
a fat young shopgirl who treated me like a noble-
man, despite the fact that I'm totally disfigured.
I saw two fat children in front of a television set.
The picture was distorted beyond recognition, yet
they were staring at it, spellbound. At the market
was a boy on crutches, leaning against the wall of
a house as my feet refused to cooperate anymore.
With a single, brief exchange of glances we meas-
ured the degree of our relationship.

All I see in front of me is route. Suddenly, near the crest of a hill, I thought, there is a horseman, but when I moved in closer it was a tree; then I saw a sheep, and was uncertain as to whether or not it would turn out to be a bush, but it was a sheep, on the verge of dying. It died still and pathetically; I've never seen a sheep die before. I marched very swiftly on.

In Troyes there had been myriad clouds chasing through the morning dimness, as it started to rain. In the obscurity I went to the cathedral, and when I, the Gloomy One, had crept around it, I gave myself a push and went inside. Inside, it was still very dim; I stood silently in a forest of giants that had once gloomed ages ago. Outside, it stormed so fiercely that my poncho tore; I swung forward from bus stop to bus stop, seeking refuge in the covered shelters. Then I left the intolerable main route and walked parallel to it alongside the Seine. The region

was very disconsolate, like outskirts that refuse
to stop, interspersed with a few farmhouses. The
electrical cables howled and swayed in the storm;
I walked bent forward a bit to avoid being blown
off my feet. The clouds were no higher than three
hundred feet at most, just one big chase. Near a fac-
tory a guard screamed at me from behind, thinking
I intended to enter the premises, but I was merely
keeping away from the trucks carrying huge foun-
tains on them. It's impossible to walk across the
fields, everything's flooded and swampy. Yonder
where the land is plowed the soil is too ponderous.
Fortified by the weather, it was easier to confront
faces today. My fingers are so frozen that I can
write only with a great deal of effort.

All at once driving snow, lightning, thunder,
and storm, everything at once, directly overhead,
so suddenly that I was unable to find refuge again
and tried instead to let the mess pass over me, lean-
ing against the wall of a house, halfway protected
from the wind. Immediately to my right at the cor-
ner of the house, a fanatical wolfhound stuck his
head through the garden fence, baring his teeth at
me. Within minutes a layer of water and snow was

lying hand-deep on the street, and a truck splashed
me with everything that was lying there. Shortly
afterward, the sun came out for just a few seconds,
then a torrential rainfall. I grappled forward from
cover to cover. At the village school in Savières,
I debated whether I should drive to Paris, seeing
some sense in that. But getting so far on foot and
then driving? Better to live out this senselessness,
if that's what this is, to the very end. Saint-Mesmin,
Les Grès. I didn't quite make it to Les Grès, due to
my escapes from the enormous black wall racing
toward me. I broke into the laundry room of an
inhabited house, noticed by no one. For five minutes
the Infernal reigned outside. Amid thick lumps of
hail blowing horizontally outside, birds were fight-
ing. In just a few minutes the whole Thing swept
over me, leaving everything white, an unsteady
sun twitching in pain afterward and, beyond it,
deep and black and threatening, the next wall
approached. In Les Grès, shaken to the soles, I
ordered a café au lait. Two policemen on motorcy-
cles, wearing rubber uniforms that made them look
like deep-sea divers, likewise sought shelter. Walk-
ing doesn't work anymore. The blizzard made me

laugh so hard that my face was all contorted when I entered the café. I was fearful the police would seize me, and so in front of a bathroom mirror once more I quickly made sure that I still looked somewhat human. My hands are slowly getting warm again.

Walked a long way, a long way. Far off in the open fields, when another one of those stormy fits came and there was no shelter near or far, a car stopped and took me a little way to Romilly. Then onward. I stood leaning against a house, directly under a window, during a hailstorm, as again there was nothing better to be found in such haste, and there was an old man inside—so close I could have grabbed him with my arm—who was reading a book by the light of a table lamp. He didn't realize anything was pouring down outside, nor did he see me standing nearby, breathing on his windowpane. My face, assessing it in a mirror again since an idea was stirring, wasn't altogether known to me anymore. I could swim the rest of the way. Why not swim along the Seine? I swam with a group of people who fled from New Zealand to Australia, in fact I swam in front, being the only one who knew the route already. The only chance the refugees had of

escape was to swim; the distance, however, was
fifty miles. I advised people to take plastic soccer
balls with them as additional swimming aids.
For those who drowned, the undertaking became
legendary before it even began. After several days
we reached a town in Australia; I was the first one
to come ashore, and those who followed were pre-
ceded by their wristwatches, which drifted in half-
underwater. I grabbed the watches and pulled the
swimmers ashore. Great, pathetic scenes of broth-
erliness ensued on shore. Sylvie Le Clezio was
the only one among them whom I knew. When it
started to rain very hard again, I wanted to seek
shelter in a roofed bus stop, but there were already
several people there. I hesitated before finally creep-
ing over to a school for cover. The gate that served
as an entrance for cars closed shut, making some
noise, and the teacher eyed me from the classroom.
At last he came outside in sandals and blue overalls
and invited me into the classroom, but the worst
was over by then, and I was too much into the
rhythm of walking to be able to rest very long.
The distances I cover now are quite large. When

I left I replaced the iron gate in its lock very gently, so that I left without further ado. Walking endlessly up to Provins, I decided to eat prodigiously, but a salad is all I can get down. When I have to get up now, a mammoth will arise.

Thursday 12 December

Called Pierre-Henri Deleau. I've pulled him out of
bed; he's the only one who currently knows that I'm
coming on foot. Nangis: perfectly straight stretch,
pleasant to walk since I can trot along the roadside.
Cold, light snow begins to drift, then rain. It is very
cold; at the edge of the snow I encountered a police
roadblock, which became most uncomfortable. Har-
vested fields, trees on the sides of the road, heaps of
leftover sugar beets. In Provins I wandered about in
the morning for a long time, at least six miles in all.
The will to end all of this wells up in me, but from
Provins it's still fifty miles to Paris, and counting
the stretch I've already covered makes it a good
fifty-five miles. I won't stop walking until I'm there.
One night more, then another half-day. My face is
burning from the cold. Last night I slept a little bet-
ter, even if I've been waking up these past few days
at three-thirty in the morning, and slowly going on
my way. First I went to the upper part of Provins in

the darkness and imagined what a somber time it must have been a thousand years ago, as one can see from the buildings there. An almost-empty bus overtook me and, while passing, the driver opened the pneumatic doors to throw away his burning cigarette butt. Both doors opened when he did it, in the front and the back. The driver does this from habit, he almost never has any passengers to drive, the bus is almost always empty. One day a school kid, leaning against the rear door with his satchel, falls out. They find him hours later, because the only two passengers in the bus are seated further up front and didn't notice a thing. But it's too late, and the child dies that night. In court the bus driver has nothing to say in his defense. How could it be, he asks day after day, again and again. The sentence, incidentally, hasn't been passed yet. My hands are as red as a lobster from the cold. I keep walking as always.

Friday 13 December

Walked all night long, Paris perimeter. It was the day when my grandfather refused to get up from the chair in front of the door. A farmhouse was in the background, also a clothesline between a couple of rotting posts, and fixed to it were clothespins. Ducks splashed about in a small muddy hole in which water had gathered. At a distance, a barn and a cottage, the kind they provide for retired railway clerks. On the railway tracks just one train a day passes through. My grandfather was sitting in his leather armchair, wrapped in a rug up to his chest. Without any explanation he refused to leave the chair from then on. Since the weather was fine, they let him have his way, later building some sort of temporary stall around him, the walls of which were built in such a manner that one could remove them quickly and easily when it was warm again outside. The roof is nailed down with tar paper over

it. Behind Grandfather, the first building past the
farmhouse is the inn. All kinds of things are written
on the menu, but the waitress always says, we're out
of this today, and that's just finished, and there's
nothing left in the way of pork, the butcher's been
remiss with his deliveries. Only fish remains, several
varieties, and it's been like this every day since the
restaurant first existed. The tables are separated by
aquariums, inside of which carp, trout, and, also,
some very exotic fish are incarcerated, among them
a trembling eel capable of giving out violent electric
shocks. But these fish are never taken out and made
into dishes; where the kitchen gets its fish remains
a mystery. "When I suffer from hunger, I suffer a
lot" is inscribed across every aquarium, and when
crumbs are thrown into the water from above,
the fish fight for them. Grandfather once let it be
known that he felt all his vertebrae were broken,
with everything held together only because he was
sitting in the arms of the chair. If he stood up, all
would fall apart like a pile of stones. You could see
this from the collarbone, and making a circular
movement with his shoulder, which he pretends

isn't possible with the other side, he considers this valid proof that his collarbone has no solid connections to the crumbled spinal column, at least not on the left side. For eleven years Grandfather sat in his armchair; then he got up, went into the inn behind his stall, ordered something to eat, ate fish, and when he wanted to pay, the money he had in his pockets had become invalid, the banknotes having been replaced years ago. Grandfather then visited his old sister, going to bed there and then refusing to leave it again. Grandmother couldn't understand this anymore, but the sister could. Every day Grandmother came and tried to talk Grandfather into getting up, but he didn't want to listen. After nine months Grandmother came just once a week instead of daily, and so it remained for forty-two years. At the time of their golden wedding anniversary she came twice in one week, on two consecutive days, for the wedding date fell on the day before her regular visit. The trip was rather long, Grandmother always took the tram. But after many years the tram was shut down, the rails ripped out of the street, and a bus line opened. Each day when

Grandmother came she carried Grandfather's boots with her to show to him and tried to persuade him to put them on and get up. After forty-two years there was a little accident. Grandmother was shoved out of the bus by pushing passengers, lost the plastic bag with the boots, and, before she could pick them up again, the moving bus ran over the boots. What now? Before Grandmother visited Grandfather she bought a new pair of boots. When Grandfather saw the new boots, he became curious, wondering whether they would hurt him. He put on the boots, got up, and went away with Grandmother. Two and a half years later, Grandfather died after an evening of bowling, during which he had won every game. He died because of his joy, which had simply been too much for his frail heart.

The sight of a large forest in the storm. All day long there was rain, all night long it was wet and cold, mixed with snowflakes. Over there are fragments of a mobile home, of gloves that I found, the walk through the night, the accident, the Russian reception. The hill in the city is the accumulated debris from the age of Louis XIV, at which time it

was open countryside, and the filth has piled up so high that there is a regular mountain in the city today, with paved streets and skyscrapers on it.

I looked for Claude's arrow, which he had shot into a tree trunk years ago and which all this time had been stuck firmly in the trunk, but it had rotted away and recently fallen off, he said; when he retrieved it, only the steel point was still sticking into the tree. Birds had used the arrow often as a landmark and a branch, said Claude; he'd see five, six blackbirds on it sitting in a row. He claims he still has the small, parched lemon he picked in In-Gall, from the first tree he saw after crossing the Sahara. The powder and ammunition for the hunt he produced himself, he even made the rifle himself.

In the morning I had reached the edge of Paris, but it was still a half-day to the Champs-Élysées; I walked there on feet so tired that I had no more consciousness left. A man wanted to walk through the forest and never appeared again. A man went for a solitary stroll on a broad beach with his big dog. He had a heart attack and, since the chain was wrapped around his wrist, he was forced to walk on and on, as the dog was very rash and wanted to run.

A man had a live duck in his shopping bag. A blind beggar played the accordion, his legs covered with a zebra-striped blanket below the knee. The woman beside him was holding the aluminum cup for the money. Next to them they also had a shopping bag, out of which peered a sick dog. A sick dog attracts more money. Often my gaze strayed through a window on to a vast sandy beach. There were powerful waves, pounding surf, and nothing but haze at daybreak. Hias says he sees to the end of the world. We were close to what they call the breath of danger.

Several waiters took up the pursuit of a dog that had run out of a café. A slight incline had been too much for an old man, and he pushed his bicycle, walking heavily, limping and panting. Finally he stands still, coughing, unable to go on. On the rack behind him he has fastened a frozen chicken from the supermarket.

Must hunt Peruvian harp music with female singer. Exalted hen, greasy soul—

Saturday 14 December

As afterthought just this: I went to Madame Eisner, she was still tired and marked by her illness. Someone must have told her on the phone that I had come on foot, I didn't want to mention it. I was embarrassed and placed my smarting legs up on a second armchair, which she pushed over to me. In the embarrassment a thought passed through my head, and, since the situation was strange anyway, I told it to her. Together, I said, we shall boil fire and stop fish. Then she looked at me and smiled very delicately, and since she knew that I was alone on foot and therefore unprotected, she understood me. For one splendid, fleeting moment something mellow flowed through my deadly tired body. I said to her, open the window, from these last days onward I can fly.

Tribute to Lotte Eisner

*On the evening of March 12, 1982, seven years after*
*Herzog's journey to Paris, he gave the following speech in*
*honor of Lotte Eisner on the occasion of her receiving the*
*Helmut Käutner Prize for her contribution to German film*
*culture. She was the first person to be given this award.*

Ladies and Gentlemen,

Today we are honoring Lotte Eisner, our Iron
Lady.[1]

Bertolt Brecht, who with his impertinence usu-
ally said the right thing, was the first to call her
that, and it has since taken root.

Our Eisner—who is that? I will say it right from
the start: she is the conscience of all of us, the con-
science of New German Cinema, and, since Henri
Langlois is now dead, probably the conscience of
the entire film world. Having fled from the bar-
barism of the Third Reich, she survived and is now
with us, on German soil. That you, Lotte Eisner,

ever even reentered this country is one of the miracles that has fallen into our lap.

Blessed are the hands of those who have awarded her the Helmut Käutner Prize, blessed is the place here in Düsseldorf where she sits among us, and blessed, ladies and gentlemen, is your affection, to which your presence attests.

Langlois, the dragon who guarded all of our treasures, the brontosaurus, this wondrous monster, has left us and now we just have our Eisner. Lotte Eisner, I welcome you and honor you as the last mammoth left on earth, as the only living person on this earth who knows cinema from its moment of birth onward. Or, to be more exact: you have personally known—and often encouraged—everyone of any significance since the beginning of film: the magician Méliès, who shot his films between 1904 and 1914 (of course, you got to know him only afterward), then Eisenstein, Chaplin, Fritz Lang, Stroheim, Sternberg, Renoir, everyone. And there was no one who did not revere you.

That was the case with the following generation as well as the current one—my generation. Madame Eisner is the destination of our pilgrimages, and in

her small apartment in Paris one finds predominantly young people who gather around her because her spirit has remained young. Only your body has become old and tiresome and a terrible nuisance since you would probably much rather climb mountains with us.

Lotte Eisner, I will not keep secret here that shameful moment when you cowardly wanted to steal away from us and out of this life. That was 1974 and we, the New German Cinema, were still just a delicate plant, lacking deep roots in the ground, still ridiculed as "movie kids." We could not allow you to die. I myself attempted at the time to implore fate. I wrote then—forgive me that I quote it here:

> Our Eisner mustn't die, she will not die, I won't permit it. She is not dying now because she isn't dying. Not now, no, she is not allowed to. My steps are firm. And now the earth trembles. When I move, a buffalo moves. When I rest, a mountain reposes. She wouldn't dare! She mustn't. She won't. When I'm in Paris she will be alive. She must not die. Later, perhaps, when we allow it.

Lotte Eisner, we want you with us even when you are a hundred years old, but I herewith release you from this terrible incantation. You are now allowed to die. I say that without any frivolity, with deep respect for death, which is the only thing we can be sure of. I also say it because we have been strengthened through you, because you have made our connection to our own history possible. And even more important: because you have given us legitimacy.

It is strange that the continuity in German film was torn asunder by the catastrophe of the Second World War. The thread had actually run out even earlier. The path led nowhere. And with the exception of just a few films and directors like Staudte and Käutner, German film no longer existed. There was a gap of an entire quarter century. That was not as dramatically felt in the field of literature and in other areas. We, the new generation of filmmakers, are a fatherless generation. We are orphans. We have only grandfathers—Murnau, Lang, Pabst, the generation of the 1920s.

Your books, above all your book on expressionist German film, *The Haunted Screen* (I am certain it will remain the definitive, the conclusive study of

this epoch), as well as your book on Murnau and the one on Fritz Lang, then your work at the Cinemathèque in Paris and your sympathy with our fate, that is, the fate of the young—all this provided us with a bridge to our historical and cultural context. No one else will ever understand what this means—not the French, who were affected by the same catastrophe but still continued on almost seamlessly; not the Italians, who immediately after the war created neorealism; and also not the Americans and the Soviet Union. No one. Only we can appreciate it fully.

When I arrived at your place, exhausted, mocked, and at my wit's end, you remarked at one point in passing: "Listen, film history does not permit you young filmmakers in Germany to ever give up."

The second thing of special value to us is the question of legitimacy. I declare and insist, as I have insisted for many years now: *we once again have a legitimate film culture in Germany*. So that you understand me correctly, ladies and gentlemen, I say that as a contrast to all the barbarism and horrors that the Nazi period brought upon us. But we are not simply, so to speak, legitimate by virtue of

our own authority. Rather, our Eisner, the ultimate authority for us, made us legitimate. Through her we were granted legitimacy. Perhaps I might explain it this way: whenever someone in the Middle Ages was crowned emperor, it happened on the basis of succession or above all through power, but he had to get his legitimacy from the pope in Rome. Because our Eisner declared us legitimate, we are legitimate. And that made it possible to reach an international audience.

Our Eisner—who is that? I ask the question for the second time. Lotte Eisner, what you mean to us today was not something that could be immediately foreseen in your life. Even now you are still angry with your mother that you were not a boy or an Indian. As a five-year-old you read Karl May and wanted to become an Indian.[2] You built a wigwam of rugs and scalped your dolls. You were drawn to the sagas of classical antiquity, and that at an age when children normally do not even know how to read. Later, under your desk at school you read Dostoyevsky. You became an archaeologist and art historian, and in a roundabout way you are a kind of archaeologist again today. You discover and

unearth. A school friend once told you about a charming rascal who claimed to be a serious author. He had written a play in one of his notebooks, and you were supposed to read it because your friend (who didn't understand anything about literature) wanted to have an affair with him if the play turned out to be any good. The title of the play was *BAAL*. "Listen," you said after you had read it that night, "he will be the best author in Germany!" Back then this writer did not call himself Bertolt, but rather Eugen. That was 1921.

The archaeologists seemed to you like cooks who cut lettuce leaves into small squares, and you also didn't want to gather dust as a director in a museum. Your dissertation advisor counseled you back then: "I can see from your dissertation that you know how to write. So write!" You wrote about literature, about theater, and you were in close personal contact with Max Reinhardt and everyone great that came out of theater and literature in the 1920s. But then the passion for film overtook you, and you are still burning with it today.

In 1933 you wrote about the film *Poison Gas* by Harry Piel, and you wanted to open the eyes of your

readers to a horrific vision that dawned on you.[3] The *Völkische Beobachter* retorted verbatim: "The *Film-kurier* takes off its mask. The Bolshevistic Jewish journalist Lotte Eisner" wrote such and such.[4] And then it continued word for word, one hesitates to repeat it: "When heads roll, this head will roll." Upon Hitler's seizure of power—on the same evening, in fact—you, Lotte Eisner, left Germany for good, chased away like many of the best that this country had to offer. Your siblings hesitated to follow you. "You'll be lucky," you told them, "if later they even let you bring along a suitcase."

During the occupation in France you lived hidden under a false name. You survived. You have requested that your ashes be scattered in a forest in France.

Then you worked again, and together with Henri Langlois you saved thousands of silent films that would have been lost forever. You wrote your books, which have been so important for us. You continued to unearth and discover. And without hesitation you turned your attention to us filmmakers who, with some difficulty, were just getting our first films going. You gave us wings, I mean that quite literally.[5]

With your permission, Lotte Eisner, may I read to you, ladies and gentlemen, what I wrote shortly before Christmas 1974, when my grim pilgrimage was over:

As afterthought just this: I went to Madame Eisner, she was still tired and marked by her illness. Someone must have told her on the phone that I had come on foot, I didn't want to mention it. I was embarrassed and placed my smarting legs up on a second armchair, which she pushed over to me. In the embarrassment a thought passed through my head, and, since the situation was strange anyway, I told it to her. Together, I said, we shall boil fire and stop fish. Then she looked at me and smiled very delicately, and since she knew that I was alone on foot and therefore unprotected, she understood me. For one splendid, fleeting moment something mellow flowed through my deadly tired body. I said to her, open the window, from these last days onward I can fly.

Lotte Eisner, I am not the only one you have given wings. I thank you. And I thank you, ladies and gentlemen, for your kind attention.

Except for the opening address and final sentence, the
text follows "Die Eisnerin, wer ist das?" in *Der alte
Film war tot. 100 Texte zum westdeutschen Film,* ed. Hans
Prinzler and Eric Rentschler (Frankfurt/Main: Verlag
der Autoren, 2001). The essay was originally published
in German in 1982 in the journal *Film-Korrespondenz.*

1. The German is "die Eisnerin," a wordplay on Lotte
Eisner's name. *Eisner* was a term for someone who sold
wares made of iron, the iron seller or iron man. *Eisnerin*
would be the made-up feminine form of this term, iron
lady. Because the wordplay does not come across in
English, this neologism will be translated as "our Eisner"
or "Madame Eisner."

2. Karl May (1842–1912) was one of the most popular
German authors of all time. Many of his most famous
novels were set in the American "Wild West" and fea-
tured German gunslingers, who were often allied with
noble Indians.

3. This 1932 film written and directed by Harry Piel
is usually referred to as *Der Geheimagent (The Secret
Agent).* In the film Piel plays the secret agent Harry
Parker, who seeks the formula for a dangerous poison

gas before secret agents from enemy nations get it first. Piel joined the Nazi Party in 1933, only to fall afoul of Nazi censors during the war.

4. Beginning in 1920, *Der Völkische Beobachter* was the newspaper of the Nazi Party. The *Film-Kurier,* which began publication in 1919, was one of the period's most influential German magazines devoted to film.

5. The original German word is *beflügeln,* which means "to inspire." Because it contains the German word for "wing," it can be literally rendered as "to be-wing."

WERNER HERZOG was born in Munich and grew up in a remote mountain village in Bavaria, where he never saw any films, television, or telephones as a child. During high school he worked the night shift as a welder in a steel factory and made his first film in 1961 at the age of nineteen. Since then he has produced, written, and directed more than sixty films, such as *Nosferatu the Vampyre* and *Grizzly Man*; published more than a dozen books of prose; and directed many operas.